Gilles Néret

PETER PAUL RUBENS

1577–1640

The Homer of Painting

TASCHEN

KÖLN LONDON LOS ANGELES MADRID PARIS TOKYO

COVER:
Susanna Fourment or `Le Chapeau de Paille' (detail), c. 1622
Oil on wood, 79 x 54 cm
London, The National Gallery
Photo: Artothek / Bridgeman Art Library

BACKCOVER:
Self-Portrait (detail), 1623
Oil on wood, 86 x 62.5 cm
Windsor, Windsor Castle, The Royal Collection
The Royal Collection © 2003, Her Majesty Queen Elizabeth II

ILLUSTRATION PAGE 1:
Study for a Self-Portrait (detail), 1611–1614
Oil on wood, 78 x 61 cm
Florence, Galleria degli Uffizi

ILLUSTRATION PAGE 2:
Susanna Fourment or `Le Chapeau de Paille', c. 1622
Oil on wood, 79 x 54 cm
London, The National Gallery

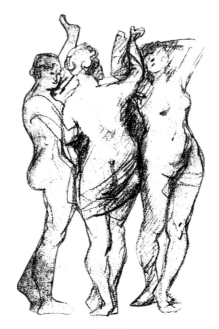

ABOVE:
The Three Graces, c. 1632–1636
Drawing, 26 x 17 cm. Private collection

© 2004 TASCHEN GmbH
Hohenzollernring 53, D–50 672 Köln
www.taschen.com
Text and conception: Gilles Néret, Paris
Editing and images: Ines Dickmann, Cologne; Béa Rehders, Paris
Editorial coordination: Kathrin Murr, Cologne
Translation: Chris Miller, Oxford
Cover: Gilles Néret, Paris

Printed in Germany
ISBN 3-8 228-2885-8

Contents

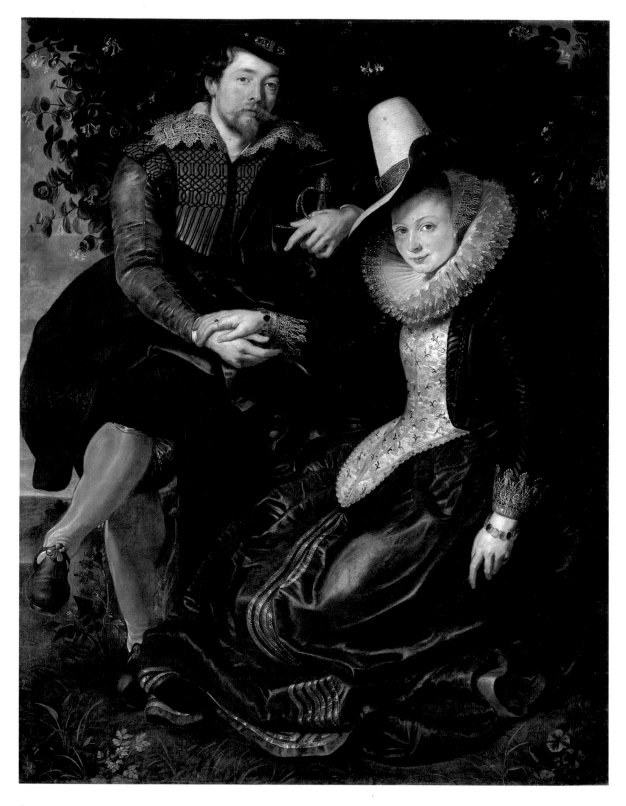

Painter, Courtier, and Envoy
1600–1620

"All that pink flesh, all those buxom nudes!" The exuberance of Ruben's style often evokes such responses. For certain art historians he is "the king of the Baroque"; Baroque painting often verges on the Romantic, they add, and few painters so perfectly illustrate this convergence. "No such thing," others retort: "Romanticism is a kind of madness, an unhealthy and humourless art, in which man sets nature at defiance and is crushed by it. Who could be more remote from such madness than Rubens, a thoroughly grounded man, cheerful, equable and the image of health?" Health and vigour he had almost to excess, using his art to master nature apparently without effort, and therefore representing man – and more especially womankind – as effortlessly dominant. Perhaps, then, Rubens is simply a classic. If so, he is alone in creating a classicism of such exuberance, one that absorbs the sweeping movement, contortions and overt theatricality of his style. It is said of his artistic lineage, of Delacroix for example, that he is a "chastened Rubens", or of Renoir that from Rubens he inherited his passion for painting full-bodied women of all but palpable flesh.

There are degrees of classicism, which the Greek classical orders perfectly illustrate. Let us review them in our effort to define Ruben's art. The Doric represents the strictest classicism: solidity, simplicity, and virility. The Ionic shows a movement toward the supple and the feminine, thanks to its double curves, which resemble the symmetrical parting of a head of curling hair. And finally, in the Corinthian there is a rebellion against purity: its acanthus leaves surge outward, joyously festooning the geometrical structure to which they are nonetheless subservient. Rubens is, clearly, a classic of the Corinthian kind. In his compositions, the proliferating vitality shrugs aside the framework established by bare intelligence. The intellectual skeleton is clothed in flesh, *drapeggio* and storm clouds. But let us not go too far in awarding these letters patent of classicism. At some point we are forced to revert to common opinion and acknowledge in Rubens a great artist of the Baroque, and, in his greatest moments, a visionary painter. His work is a culmination, a synthesis of all the artists who preceded him, and Velázquez (one of his artistic heirs) seems already to be looking over Rubens' shoulder. He blended, assimilated, developed and amplified the diverse heritages of Caravaggio, Michelangelo, Tintoretto, El Greco and Veronese and brought his own genius to the resulting brew.

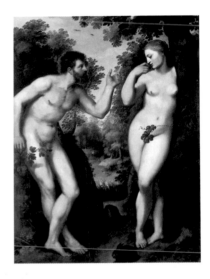

Adam and Eve, 1599–1600
Oil on wood, 180 x 158 cm
Antwerp, Rubenshuis

PAGE 6:
*The Artist and His Wife
in a Honeysuckle Bower,* 1609–1610
Oil on canvas, 174 x 143 cm
Munich, Alte Pinakothek

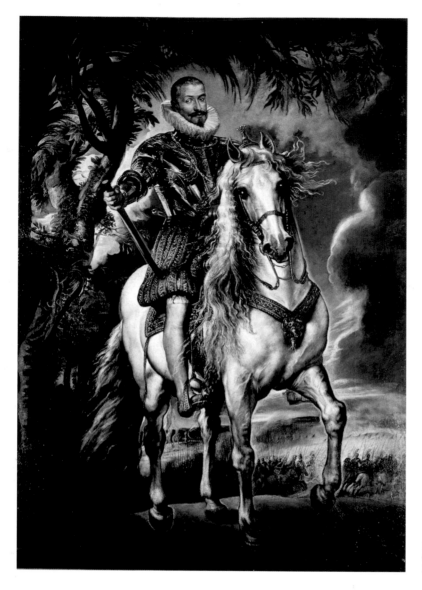

The Duke of Lerma on Horseback, 1603
Oil on canvas, 289 x 205 cm
Madrid, Museo Nacional del Prado

He is a man of both imagination and humour – no small achievement. He did not hesitate to give vent to his exuberance even in such formal compositions as the *Marie de' Medici* series, commissioned for the wife of Henri IV of France (pp. 42, 49–54). Rather than conforming to the Grand Manner expected, he had the audacity to place in the foreground, as though in provocation, the plump, lascivious Naiads, with their greedy mouths. Their nudity in rank contrast to metallic cuirass and shield, the Naiads play around the hull of the vessel, over-whelming the gorgeously-clad charms of the grand ladies, the presumable stars of the painting (detail pp. 56/57). Rubens is peerless in his ability to light a spark of the unexpected in even the most serious subjects. Even in religious paintings, he avoids the cold solemnity of historical reconstruction; he will not take him-self so seriously. The gravest and most heroic themes are subordinated to the

PAGE 9:
Portrait of the Marchesa Brigida Spinola Doria, 1606
Oil on canvas, 152 x 98.7 cm
Washington (DC), National Gallery of Art.
Samuel H. Kress Collection

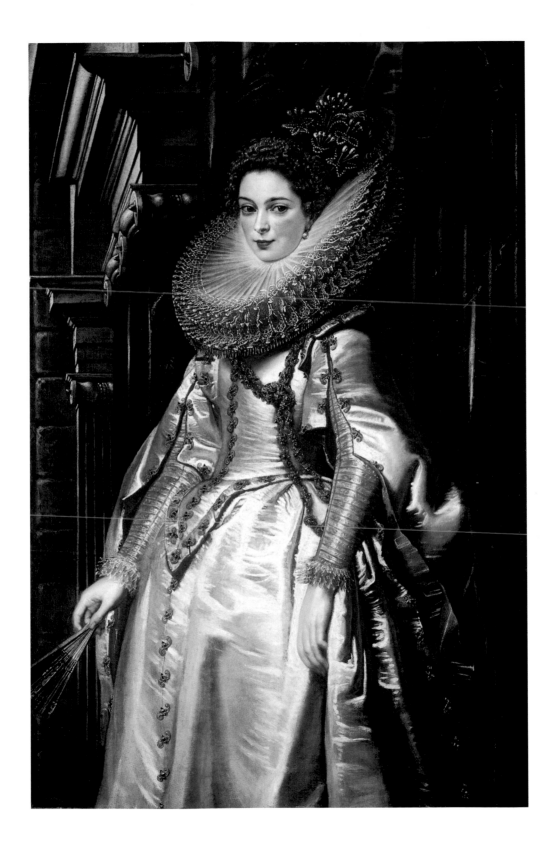

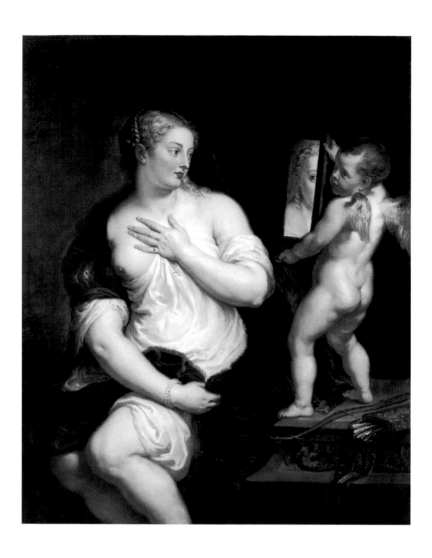

The Toilet of Venus, c. 1615
Oil on canvas, 137 x 111 cm
Madrid, Museo Thyssen-Bornemisza

play of warm and cold, of flesh and metal. This conjunction – which ensured his fame – was, in his own time, no less incongruous than Lautréamont's celebrated encounter of an umbrella and a sewing machine on a dissection table. From Rubens' colossal legacy, each subsequently extracted what attracted him, from Van Dyck to Watteau, Boucher to Delacroix, and from Renoir and early Cézanne to Matisse. But Rubens went far beyond his predecessors, and thereby intimidated his own successors. He is as intimidating to the painter as he is fascinating to the beholder.

The surging vitality that found expression in the diversity of his oeuvre, his extraordinary productivity, the power of his work and the rapidity of his execution made him, in Delacroix's words, the "Homer of painting". His passionate approach infused every subject to which he turned his hand. Profane and religious themes, mythological compositions and court portraits sprang from his palette in quick succession, and the spirit that flows through them is one and the same. The Baroque character transpires in their form, movement, rhythm, luxuriant colours, and above all in the effects – here dramatic, there grandiloquent

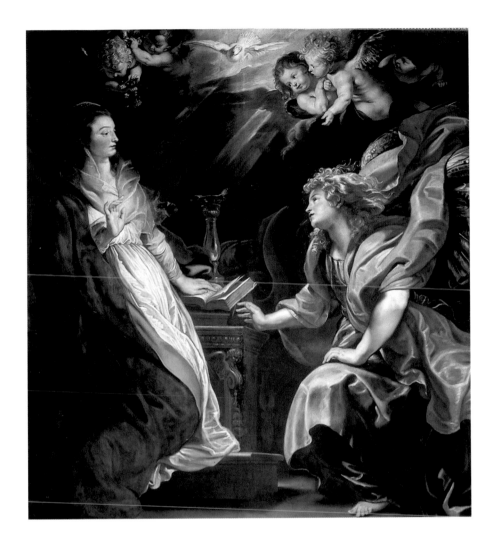

Annunciation, 1609–1610
Oil on canvas, 224 x 200 cm
Vienna, Kunsthistorisches Museum

or amorous, but invariably superabundant. Yet Rubens was perfectly able to manage the decorative requirements of his immense canvases. There he demonstrates his superlative his stage-management of effects triumphant and dramatic. It is a unique style, the Rubenesque. It is based on a systematic glorification of energy, a passionate cult of movement, and a quest for the dynamic. His compositions repose on diagonals or spirals, create whirlpools or flights of structure; unstable poses are preferred, and every face is expressive. He moved without transition from the *Assumption* of a martyr to the *Triumph* of a grandee. For every court and church in Europe, there was a Rubens. The synthesis that he contrived between his classical and Baroque manners resulted in paintings at once warmer than the classical and more harmonious than a Baroque composition. He refused to idealise, and was often criticised for allowing the appearance of his protagonists to diminish the nobility of his compositions. His madonnas and saints are too close to the flesh from which they were painted. The Virgin of the *Annunciation* (p. 11) might almost be the naked Venus in the mirror of *The Toilet of Venus* (p. 10). The Susanna of *Susanna and the Elders* (p. 14) shares not merely

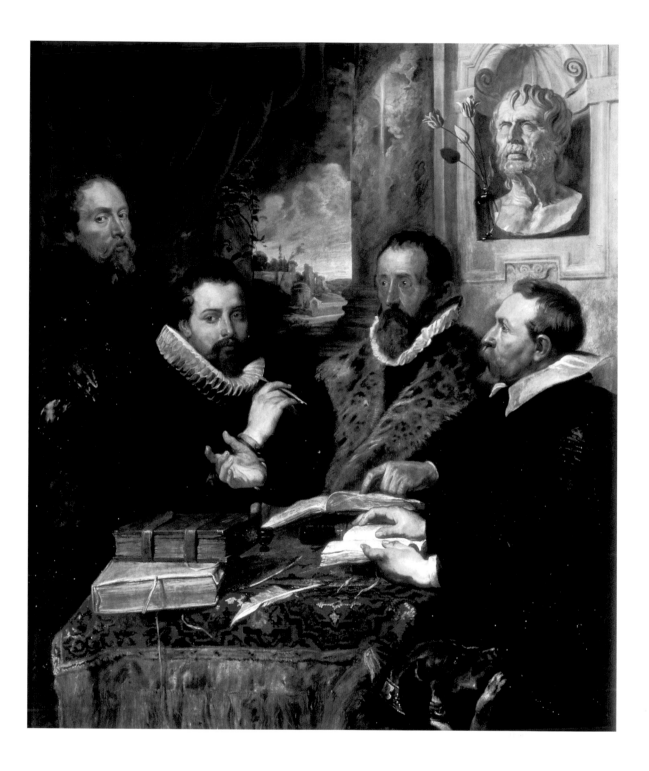

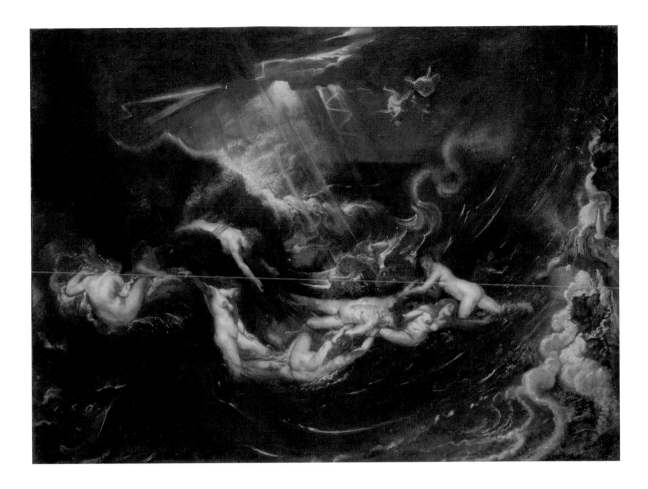

the nudity of the Christ from *The Entombment* (p. 16), but almost the entirety of his pose. The ample flesh exhibited by the *Three Graces* (p. 24) is again on display in the three women at Christ's feet in *The Last Judgement* (p. 28). Such similarities strike one throughout Rubens' corpus; he makes little distinction between Madonna and Venus, and fluttering Cupids flutter indistinguishably as cherubim. In this, he is remote from the universality of human type sought by the Italian painters of the Seicento. These bodies are too clearly inhabited; they are the expression of Rubens' own tastes, his own powerful individuality and sensibility. And there will be those who find themselves ill at ease, not so much at the pathos of the forms or the seduction of the curves, more at the excessive physicality, the immoderate realism: the pearly grain of these folds of plump flesh. One can only retort that, of all painters of the nude, Rubens most perfectly conveyed the colours and texture of the human body. Generations strove vainly to recapture the diaphanous depths and inner radiance of his "nacreous nudes".

The lyricism, eloquence and sensuality that characterise his entire *oeuvre* are already apparent in his mythological compositions of 1600–1620. These are often vigorous, earthy works: *Susanna and the Elders* (p. 22), *Venus Shivering* (p. 23), *The Rape of the Daughters of Leucippus* (p. 36), *Drunken Bacchus and Satyrs* (pp. 32–33) and *The Three Graces* (p. 24). The taste for opulent forms and buxom nudes prevailing in these works, and the vitality and pantheism they radiate, took on a more

Hero and Leander, c. 1605
Oil on canvas, 95.9 x 127 cm
New Haven (CT), Yale University Art Gallery.
Gift of Susan Morse Hilles

PAGE 12:
The Four Philosophers (Justus Lipsius and his Pupils), c. 1611–1612
Oil on wood, 164 x 139 cm
Florence, Palazzo Pitti

intimate and even elegiac note in the latter stages of Rubens' life. This is especially noticeable when he comes to paint his last love, *Helena Fourment* (pp. 64 and 67). She is also seen in *The Garden of Love* (pp. 76–77), in which the couple's marriage is celebrated, and in two related paintings, *Het Pelsken* (p. 86). Here he painted the woman deemed "the most beautiful in Antwerp": his own wife.

Rubens has always been considered one of the great European painters; his work has never fallen into oblivion. It has, indeed, scarcely fallen from fashion. But he has never enjoyed the unequivocal admiration lavished on Rembrandt, Michelangelo and even Vermeer. The unease he sometimes elicits stems from the fact that everything in Rubens is larger than life. His men and women seem engendered by a race of vigorous giants. One is reminded of Michelangelo, his fellow genius, on whose works Rubens long dwelt, on one occasion copying his *Last Judgement* in the Sistine Chapel. But where Michelangelo's nudes are beautiful young men, his models and lovers, Rubens offers greater prominence to the female nudes with which his own *Last Judgement* is abundantly furnished (p. 28).

Susanna and the Elders, 1609–1610
Oil on wood, 198 x 218 cm
Madrid, Real Academia de Bellas Artes de San Fernando

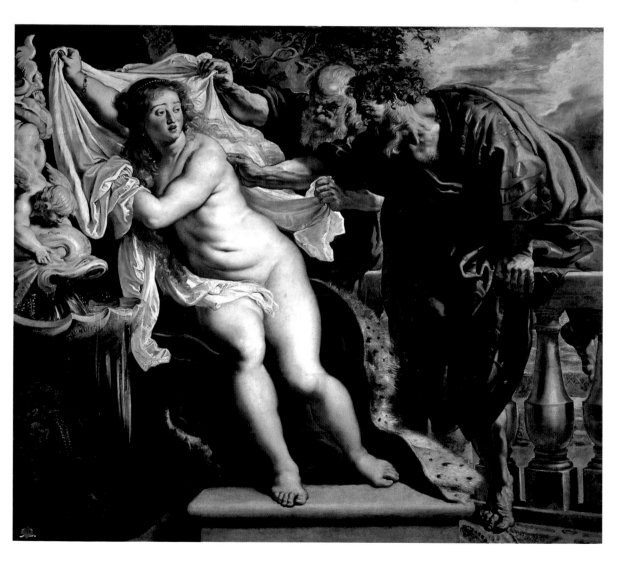

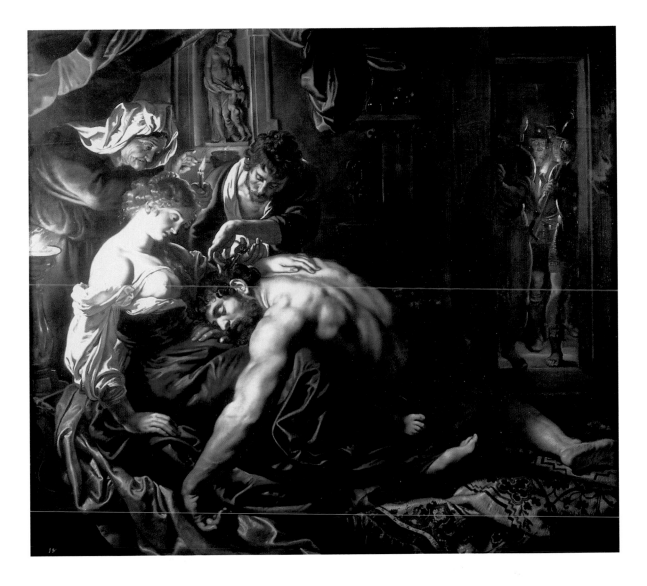

Samson and Delilah, c. 1609
Oil on wood, 185 x 205 cm
London, The National Gallery

As Edward Lucie-Smith has observed, "the relationship between the bodies of his characters and that of normal human beings is that which exists between the select language of the orator and the language of conversation". He cares little for either the fashionable ideal or pedantic realism. Neither sufficed to hold his attention. Instead, Rubens' own energy and sensual appetite find expression in his works, and constitute their undying fascination.

In short, the *sine qua non* for the genius of Rubens – that "artist *par excellence*" – was excellent health and immense energy, intelligence and talent. Furthermore, if we are to believe his friend and contemporary, General Ambrogio Spinola, Rubens' artistic gifts were merely one aspect of the man. "Of all his talents," Spinola remarked, "painting is the least". Certainly, Rubens earned a European-wide reputation as a diplomat. His success in the peace-negotiations between England and Spain in 1630 earned him a knighthood from Charles I of England. He was a scholar, a Christian Humanist, a man of letters enamoured

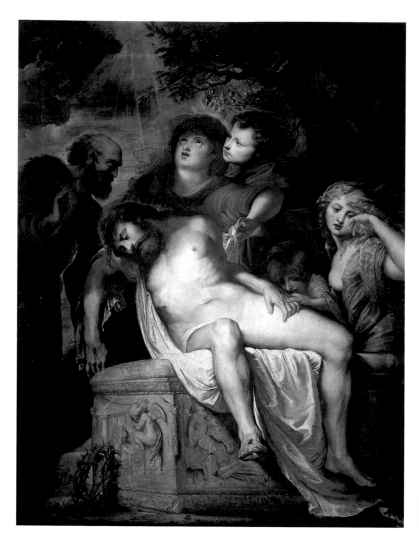

The Entombment, c. 1601
Oil on canvas, 180 x 137 cm
Rome, Galleria Borghese

of Classical Antiquity, an amateur architect, and a writer of distinction in Latin
and French who could turn his hand to Spanish and, at a pinch, to English. His
nephew Philip described Rubens' life as "one long march toward knowledge".
The Brussels court chaplain described him as "the most cultivated painter in
the world". As if this were not enough, he demonstrated considerable flair for
business, and was an organiser of genius. He built up and managed studios
that were famous throughout the continent, his goal being to train assistants
and collaborators who could serve their master's goals by transposing his ideas
into innumerable canvases, sculptures, tapestries and engravings. Rubens'
17th-century activities might be described in terms no less apt for their anachro-
nism; he was a globalizing exponent of multimedia. His artistry was rivalled
only by his energy and the range of his abilities. "I consider the whole world my
home," he observed, in strikingly modern fashion. Otto Sperling, doctor to the
Danish king, was profoundly impressed by a visit he made to Rubens' studio.
There, "the master was working on a canvas while listening to a reading of Tacitus

PAGE 17:
The Entombment, after Caravaggio, 1611–1612
Oil on wood, 88.3 x 66.5 cm
Ottawa, National Gallery of Canada

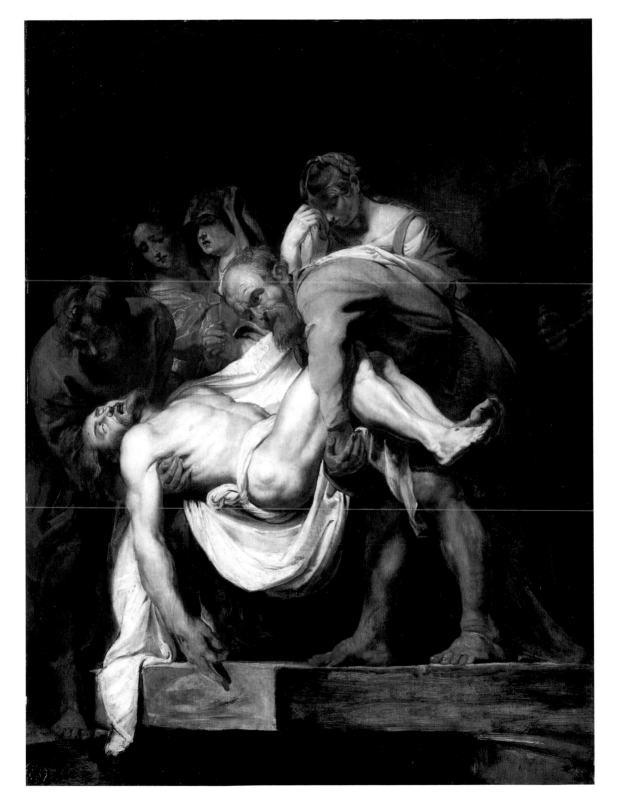

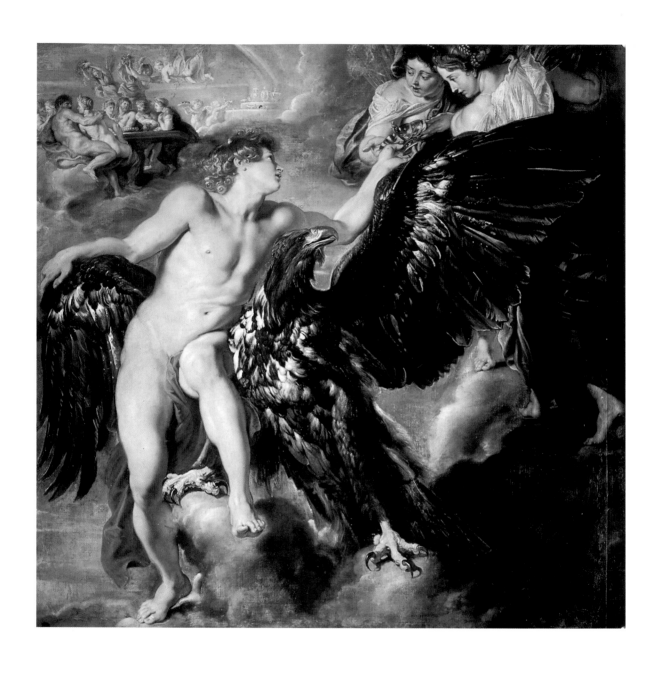

The Abduction of Ganymede, 1611–1612
Oil on canvas, 203 x 203 cm
Vienna, Palace Schwarzenberg

and simultaneously dictating a letter. Since we didn't dare interrupt him, he himself addressed us, while continuing to paint, listen to the reading and dictate his letter."

Yet the circumstances of his birth and childhood promised little enough. He was born, he believed, in Cologne, in 1577. There his family had sought refuge when the Spanish began to persecute Antwerp citizens of Protestant affiliation. His father, a brilliant lawyer, became too intimate with the woman he counselled, Anne of Saxony, wife of William the Silent [William I of Orange], and was condemned to death for this *lèse-majesté*. He was saved only by the generous and moving pleas of his wife, Maria Pypelincks, and the family went into exile yet again, this time in penurious conditions, in the small Westphalian town of Siegen. Modern scholarship has established that this was where Rubens was born. In 1587, when his father died, the family was allowed to return to Antwerp.

A man may have what it takes to succeed in life, but still need luck. Rubens made the most of his. He underwent an artistic apprenticeship in the studios of several mediocre painters before an opportunity came his way. Fortune and glory beckoned, and he seized them. In 1590, his mother's poverty forced him to enter the service of Marguerite de Ligne-Arenberg, the widow of Philippe, Count of Lalaing. There he became acquainted with the grandees of the time.

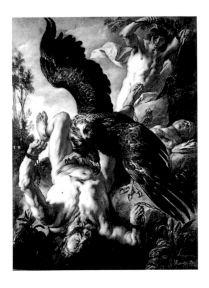

Jacob Jordaens: *Prometheus*, c. 1640
Oil on canvas, 243 x 178 cm
Cologne, Wallraf-Richartz-Museum

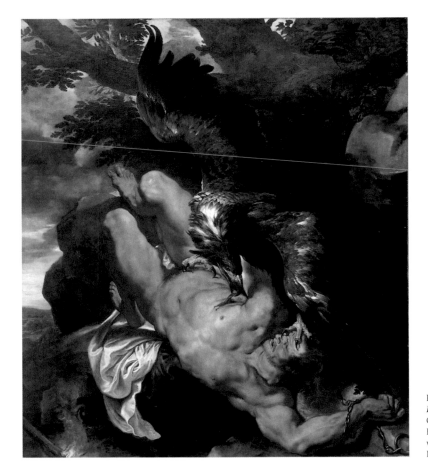

Peter Paul Rubens and Frans Snyders:
Prometheus Bound, 1610–1611
Oil on canvas, 242.6 x 209.5 cm
Philadelphia (PA), Museum of Art. Purchased
with the W. P. Wilstach Fund, 1950.
Eagle painted by Frans Snyders.

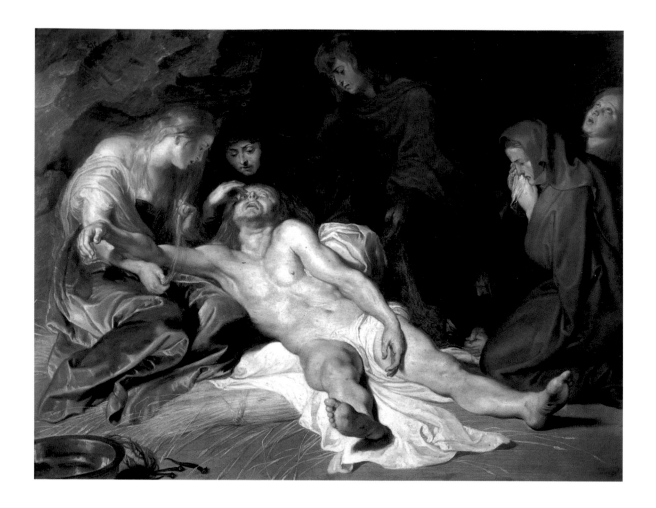

The Lamentation, 1614
Oil on wood, 40.5 x 52.5 cm
Vienna, Kunsthistorisches Museum

PAGE 21:
The Descent from the Cross, 1611–1614
Central panel of the tryptych, 1912
Oil on wood, 420 x 310 cm
Antwerp, Cathedral of Notre-Dame

And, thanks to his apprenticeship, he was admitted as a master-painter to the Antwerp Guild of St. Luke. In ten years, he had readied himself to conquer Europe. He began a series of voyages across the continent that gave him direct access not only to the masterpieces of the period – enlarging his stylistic and compositional command – but to the great men of his time; he obtained his first commissions from Italian princes. In May 1603, armed with a certificate testifying to his moral virtue, Rubens set off for Italy, anxious to further his career and study *in situ* "the works of masters ancient and modern". His first stop was Venice, where he discovered the works of Titian, Tintoretto and Veronese. Now he began copying as accurately as possible the works of his illustrious predecessors, seeking both to perfect his technique and – later – to satisfy commissions. Foremost among his antecedents was Titian, whom he always revered: "With him," he wrote, "painting came into its own". At his death, Rubens left more than twenty-one copies after Titian.

Having attracted the attention of Vincenzo Gonzaga, Duke of Mantua, Rubens entered his service, making copies and portraits for him, managing his collections and organising the court's festivities. His employment was a licence to travel the length and breadth of Italy. He was already serving as Mantuan ambassador, and already collecting commissions. In July 1601, he left for Rome,

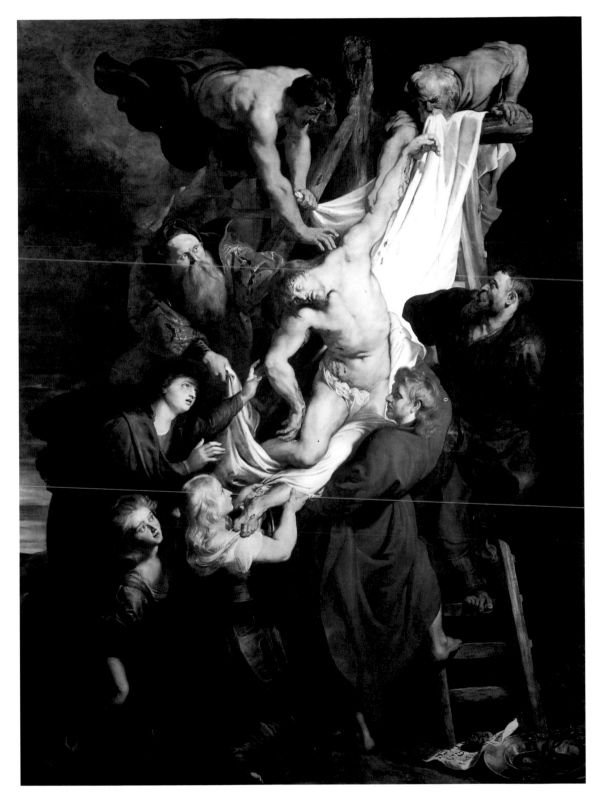

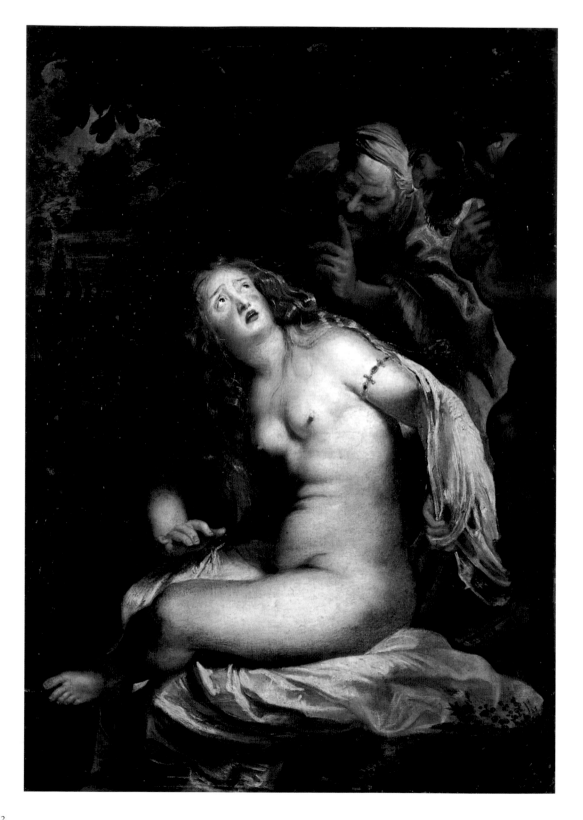

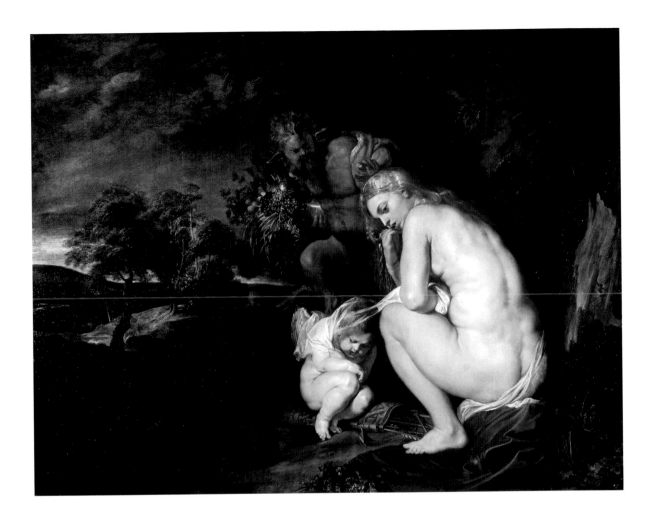

carrying a letter of recommendation to Cardinal Montalto. There, in the capital of Catholicism, he made copies of paintings by Titian, Tintoretto and Veronese, though these were no ordinary copies, displaying as they did his own powerful originality. He was also commissioned by Archduke Albert, Spanish Governor-General of the Netherlands, to paint a triptych for the St. Helena chapel in the Roman church of Santa Croce in Gerusalemme. In 1603, undertaking his first diplomatic mission to Spain, he carried gifts from Gonzaga to Felipe III; these included copies of Italian paintings by some other hand. There he attained prominence with *The Duke of Lerma on Horseback* (p. 8), now in the Prado. He also charmed the king, who commissioned a series of bust-length paintings of the twelve apostles; these too are in the collection of the Prado. These were astoundingly rapid successes, and further proof of Rubens' boundless energy. He was everywhere, and could do anything. In Mantua from January 1604 to November 1605, he received a yearly salary of 400 ducats, and it was there that he painted the most important of his early commissions: a triptych for the Gonzaga family tomb in the Jesuit church in Mantua. In Genoa, where he stayed in 1605 and 1606, Rubens practised his portraiture skills, representing the local aristocracy with splendid virtuosity. Consider, for example, the extraordinary *Portrait of*

Venus Shivering (Sine Cerero et Libero friget Venus), 1614
Oil on wood, 142 x 184 cm
Antwerp, Koninklijk Museum voor Schone Kunsten

PAGE 24:
Peter Paul Rubens and Jan Brueghel the Elder, known as "Velvet" Brueghel:
Nature Adorning the Three Graces, c. 1615
Oil on wood, 106.7 x 72.4 cm
Glasgow, Art Gallery and Museum, Kelvingrove
Cooperative work: The figures are by Rubens, the flowers and fruit by "Velvet" Brueghel, the great specialist in these subjects.

PAGE 22:
Susanna and the Elders, 1607–1608
Oil on canvas, 94 x 66 cm
Roma, Galleria Borghese

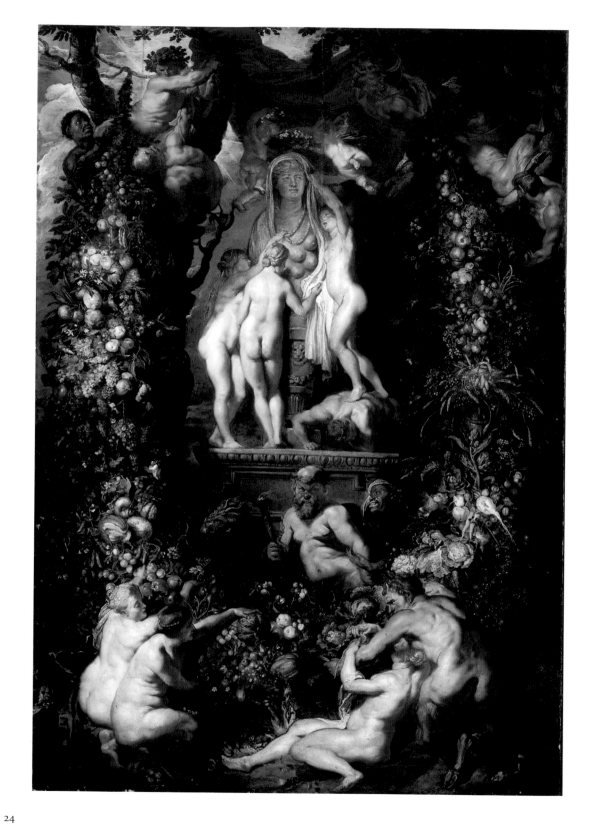

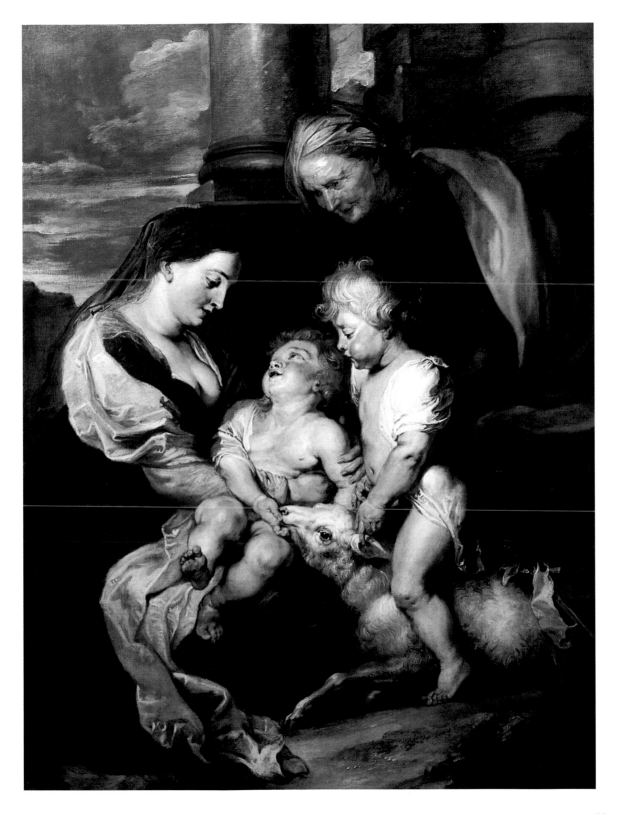

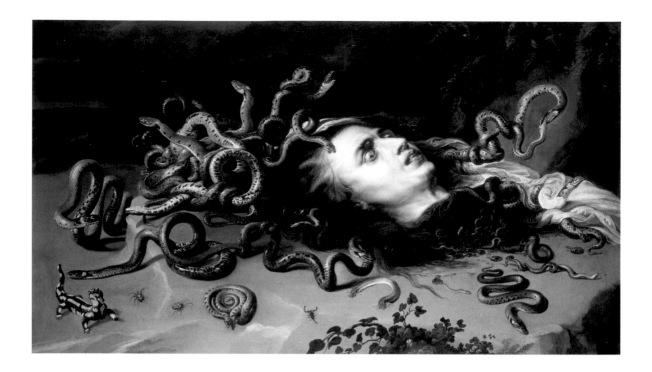

Peter Paul Rubens and Frans Snyders:
The Head of Medusa, c. 1617
Oil on wood, 68.5 x 118 cm
Vienna, Kunsthistorisches Museum
The reptiles, insects and décor are by
Frans Snyders.

PAGE 25:
*Madonna and Child with St. Elizabeth
and St. John*, 1614–1615
Oil on canvas, 153 x 110 cm
Barcelona, Monasterio de Pedralbes, Colección
Thyssen-Bornemisza

PAGE 27:
Cupid Making His Bow, 1614
Oil on canvas, 142 x 108 cm
Munich, Alte Pinakothek

the *Marchesa Brigida Spinola-Doria* (p. 9), now at the National Gallery of Art in
Washington, D.C … Rubens was only twenty-eight when he painted it, but even
at that age his works were accepted for the most historical locations, and have
since entered the most prestigious collections. With paintings such as his *Annun-
ciation* (p. 11) and *Samson and Delilah* (p. 15), he was well on the way to fame. In
1611, he returned to copying, his original this time the artist who had most im-
pressed him after Titian: his version of the latter's *Entombment* after Caravaggio
(p. 17) is now in the Canadian National Gallery.

 And now his true career began. Forced to return to Flanders in 1608 when his
mother was on her deathbed, in 1609 he was named court painter by Archduke
Albert and his wife the Infanta Isabella, the Spanish Governors in the Nether-
lands, and granted a special dispensation to reside in Antwerp (rather than Brus-
sels). That same year, he married Isabella Brant, daughter of the humanist and
lawyer, Jan Brant, one of the secretaries of Antwerp. Shortly after his marriage,
he lovingly portrayed himself hand-in-hand with his wife under a honeysuckle
bower (p. 6). By 1611 he was already rich enough to buy himself a sumptuous
house, which he gradually transformed in the style of an Italian *palazzo*; there
he established the many valuable works of art that he had begun to collect.
And commissions came flooding in. In Antwerp, he enjoyed the protection of
Nicholaas Rockox, who was first magistrate and later alderman; Rockox obtained
for him the commission for his first *Adoration of the Magi*. Three years later the
municipality presented it to the throne of Spain, and it is now in the Prado. For
the cathedral of Notre-Dame, he painted the enormous *Descent from the Cross*
(420 x 310 cm), which was intended for the Confraternity of Harquebusiers (p. 21).
In this period, too, we find Rubens gradually freeing himself of Italian influence;
in paintings such as the portrait of his wife (p. 6), *The Four Philosophers* (p. 12)
and *The Holy Family with St.Elizabeth* (p. 31), he developed into one of the great

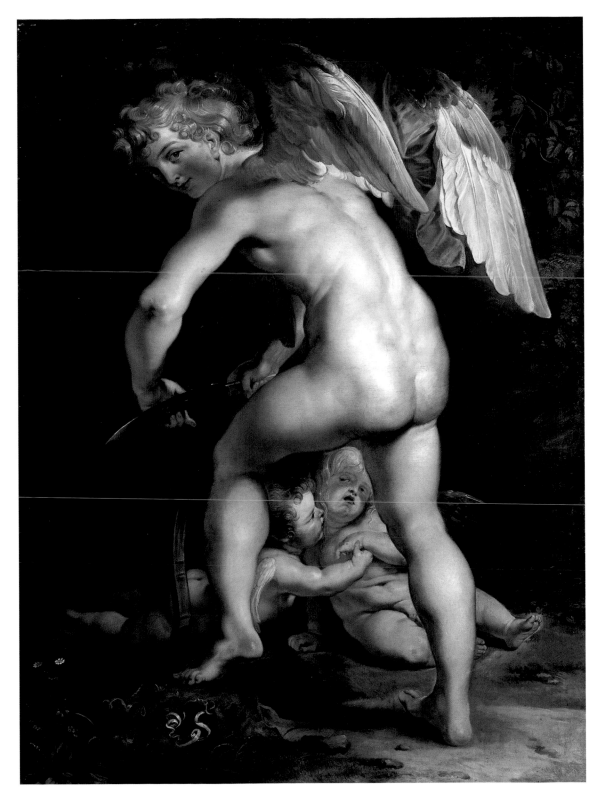

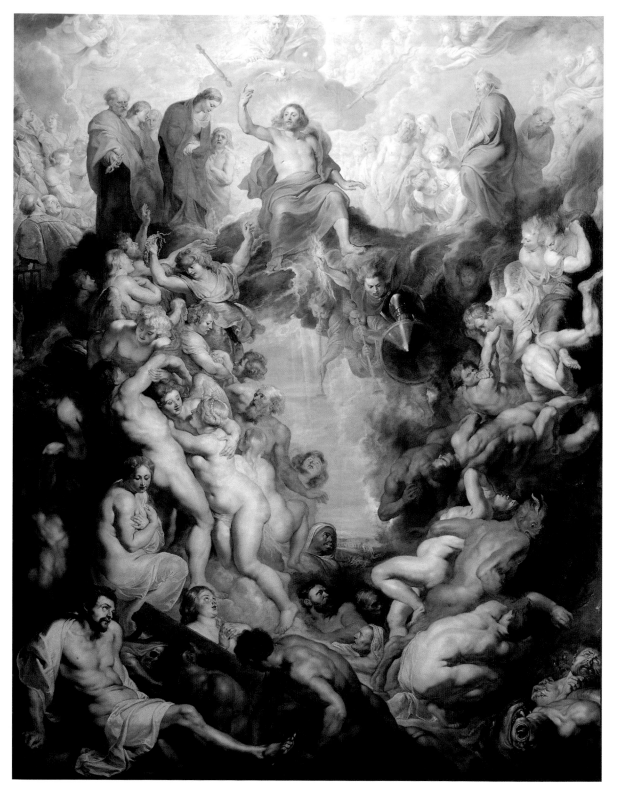

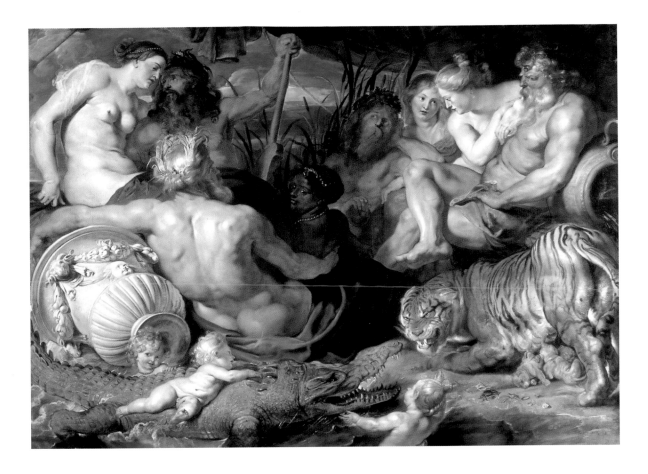

The Four Continents, c. 1615
Oil on canvas, 209 x 284 cm
Vienna, Kunsthistorisches Museum

painters of Flanders, and indeed of Christianity as a whole. His style grew ever freer. At times violent and invariably expressive, it incorporated a palette now endowed with the warmer hues of the Flemish tradition. *The Holy Family* (p. 31) has always been a favoured theme in that tradition, and Rubens painted a scene evocative of the family hearth and home, all melting strokes, light shadows, and tranquilly reflected fabrics. The blonde curls, moist eyes and fragile cheeks of the children accentuate this warmth. His wife Isabella lent her nostalgic and dreamy features to the Virgin, his son Albert modelled for St. John as he admires Jesus. Here are the homely objects of Flemish life: deep carpets, tawny furs reflecting the light, and a wicker cradle. The painting represents a turning point, the advent of his own maturity, when he threw off all constraint and approached every new subject with uninhibited passion. Thereafter, religious and mythological paintings followed in ever-increasing numbers. In form and rhythm, the luxuriance of his palette and the abundance of his effects – pathetic, dramatic or rhetorical – his art was growing ever more clearly Baroque.

He took the subject of *The Battle of the Amazons* (pp. 40/41) from Classical Antiquity; it represents the battle between Theseus's Athenians and the women-warriors of Telestris. A battle of this kind is briefly mentioned by Herodotus (4.110). The surging movement throws the opposing forces together; men, women and horses charge into combat, and the result is like an explosion within the picture space. The Amazons are hurled from their horses down into the

PAGE 28:
The Last Judgement, 1615–1616
Oil on canvas, 606 x 460 cm
Munich, Alte Pinakothek

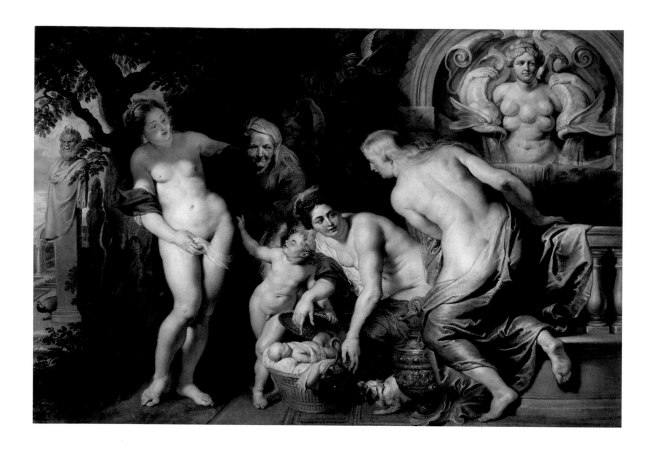

The Discovery of the Child Erichthonius, c. 1615
Oil on canvas, 217.8 x 317.3 cm
Vaduz, Sammlungen des Fürsten
von und zu Liechtenstein

PAGE 31:
*The Holy Family with St. Elizabeth ("Madonna
of the Basket")*, 1614–1615
Oil on wood, 114 x 80 cm
Florence, Palazzo Pitti

river at the base of the picture, while Theseus's horse rears up towards the upper
frame, and the wounded go swirling into the background, drawn by the current
of the River Thermodon. This is one of the most dazzling feats of Baroque paint-
ing. Rubens clearly took great pleasure in such prodigies, but was capable of
more measured virtuosity in *The Rape of the Daughters of Leucippus* (p. 36),
where the composition opens upward like the flowering of a bouquet. The two
divergent diagonals rise from the base of the painting, where the feet of captive
and aggressor are placed side by side. The volumes ascend from this point, har-
moniously residing on successive points of equilibrium, while the luminous
white forms of the nude victims contrast with the tanned, caparisoned bodies
of their hirsute rapists. Here Rubens' classicising and Baroque tendencies are
completely reconciled.

This Protean figure seemed able to move without transition from pagan alle-
gory to pious devotion. His energetic production moves from such resolutely
profane works as *The Abduction of Ganymede* (p. 18) and *Romulus and Remus*
(p. 37) to such masterpieces of the sacred as the *Christ on the Straw* (p. 38) or
Christ on the Cross ("Le Coup de Lance", p. 39). Rubens seems entirely at home
with the subject of *Bacchus* (pp. 32–33), the god of satyrs and the grape, who is
shown drunkenly tottering, his belly swollen with meat and drink, and support-
ed by a disparate collection of dotards, drunkards, blacks, children and young
women. The careless inebriation of this bacchanal is expressed by a thicker touch
that conveys the unwieldy weight of the drinkers' gait. But he is no less at home

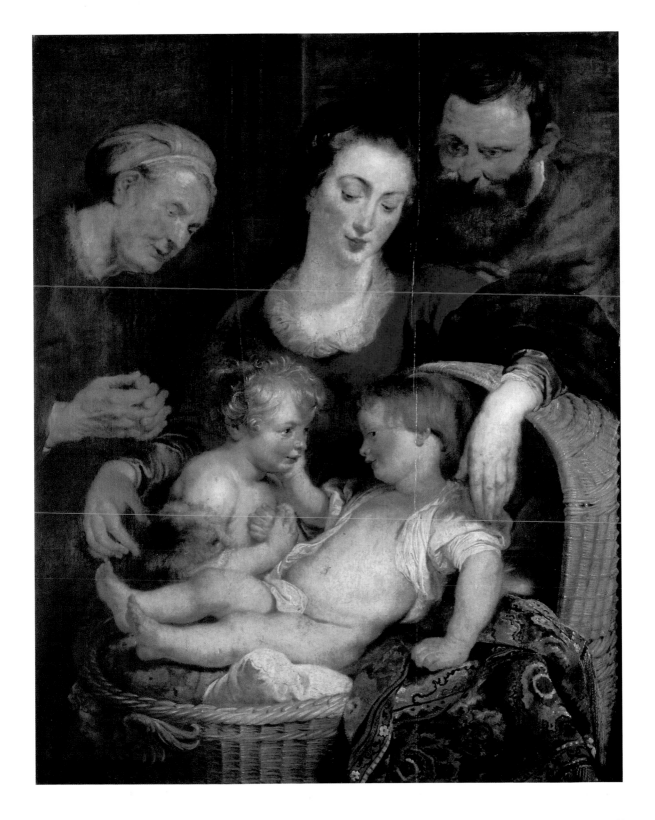

32

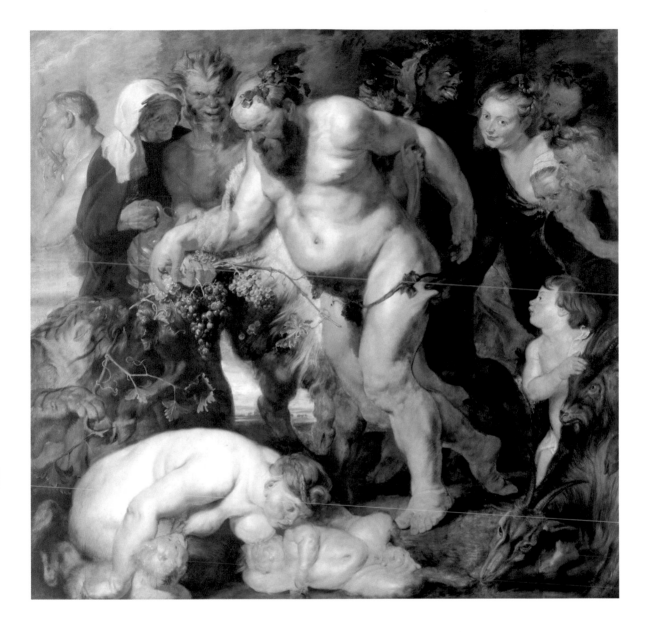

with religious revival; Rubens celebrating the tragic moments of the Passion seems, indeed, the master-painter of the Counter-Reformation. *Christ on the Cross* and *The Descent from the Cross* (p. 16) are among the most heart-rending compositions of this period. Fear of hell-fire was one of the most powerful incentives to the heretic meditating a return to the fold, but Rubens' *Last Judgement* (p. 28) enabled him, paradoxically, to enjoy an almost complete liberation in both form and composition. This gigantic work and its companion-piece, the *Fall of the Rebel Angels* (both now in the Alte Pinakothek in Munich), offer a vision of sublime terror: clusters of men and women are hurled from the celestial heights into the abyss, thrust down by grasping demons and serpents in a vast diagonal trajectory. Here only gravity seems to check the spontaneity of Rubens'

Drunken Bacchus and Satyrs, 1616–1617
Oil on wood, 205 x 211 cm
Munich, Alte Pinakothek

PAGE 32:
Bacchus and Satyrs, c. 1616
Drawing for *Drunken Bacchus and Satyrs*, 38.3 x 26.6 cm
Paris, Musée du Louvre

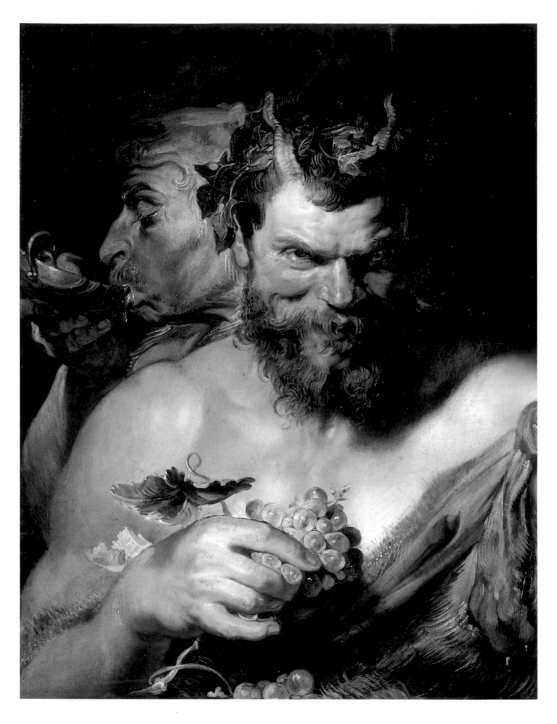

PAGE 35:
Portrait of a Young Girl (Clara Serena Rubens),
1615–1616
Oil on canvas affixed to panel, 37.3 x 26.9 cm
Vaduz, Sammlungen des Fürsten
von und zu Liechtenstein

***Two Satyrs**, 1618–1619*
Oil on wood, 76 x 66 cm
Munich, Alte Pinakothek

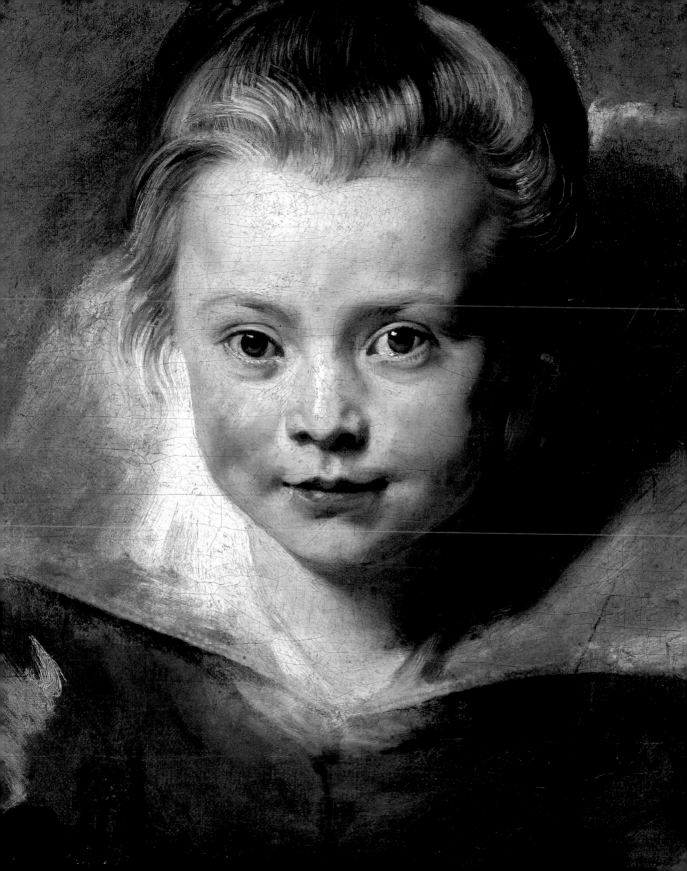

improvisatory genius. The men and women expelled from Paradise are reduced to their simple physicality, mere weight of flesh flung through sulphurous space. The heroines of Antiquity and the Bible alike inspire in Rubens the same magnificent nudes, who reflect his own ardent and sensual nature. *The Toilet of Venus* (p. 10) shows us a young woman surprised in the course of her ablutions. She is young, naked, pale and blonde, a hefty slab of Flemish beauty. *Susanna and the Elders* (p. 14) proffers the same carnal image of womankind: sensual and desirable, women are the iconic heroines of Rubens' painting.

The Rape of the Sabine Women (The Rape of the Daughters of Leucippus), c. 1616
Oil on canvas, 224 x 210.5 cm
Munich, Alte Pinakothek

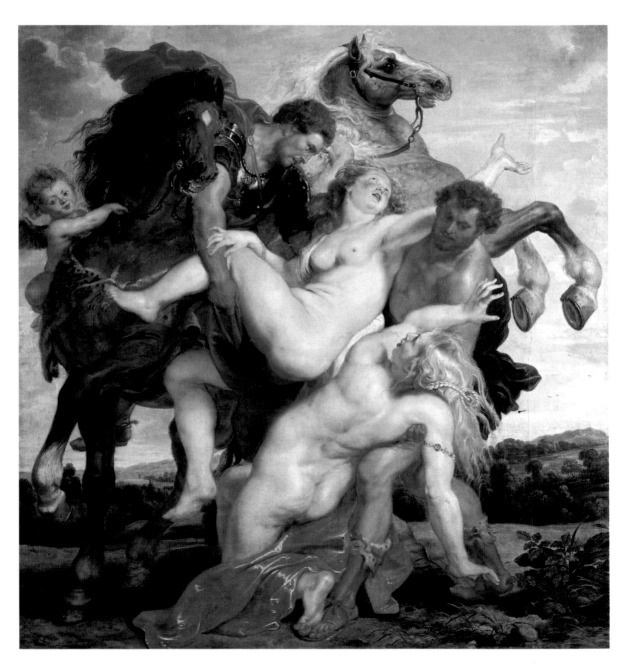

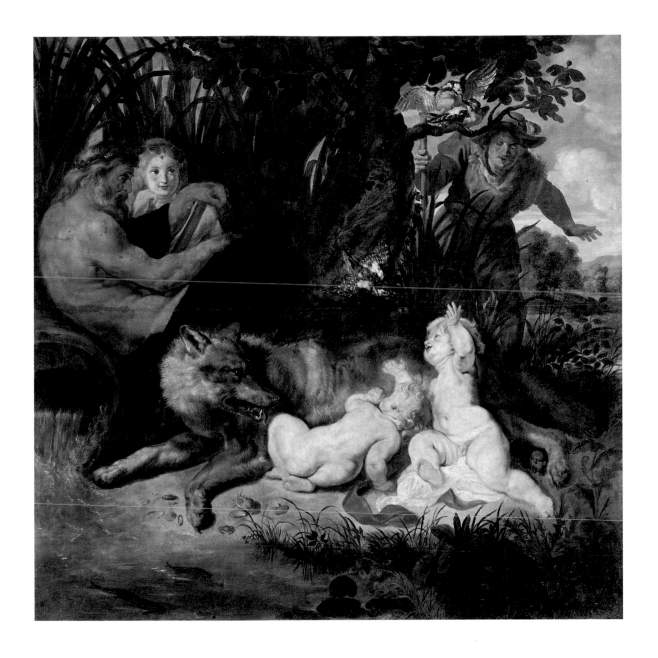

Romulus and Remus, 1615–1616
Oil on canvas, 210 x 212 cm
Rome, Pinacoteca Capitolina

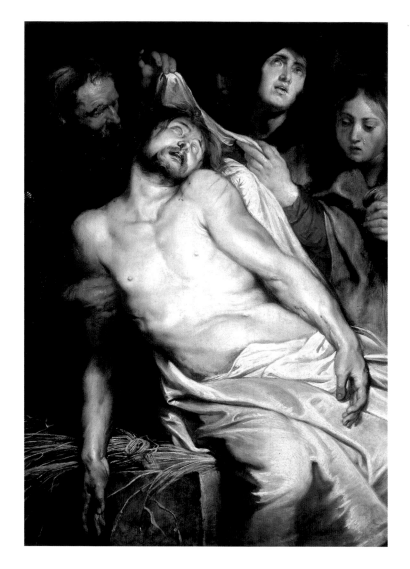

Entombment
Triptych, central panel:
***Christ on the Straw (Lamentation)**, 1618*
Oil on wood, 138 x 98 cm
Antwerp, Koninklijk Museum
voor Schone Kunsten

PAGE 39:
***Christ on the Cross ("Le Coup de Lance")**, 1619–1620*
Oil on wood, 424 x 310 cm
Antwerp, Koninklijk Museum
voor Schone Kunsten

PAGE 40/41:
***The Battle of the Amazons**, c. 1615*
Oil on wood, 121 x 165.5 cm
Munich, Alte Pinakothek

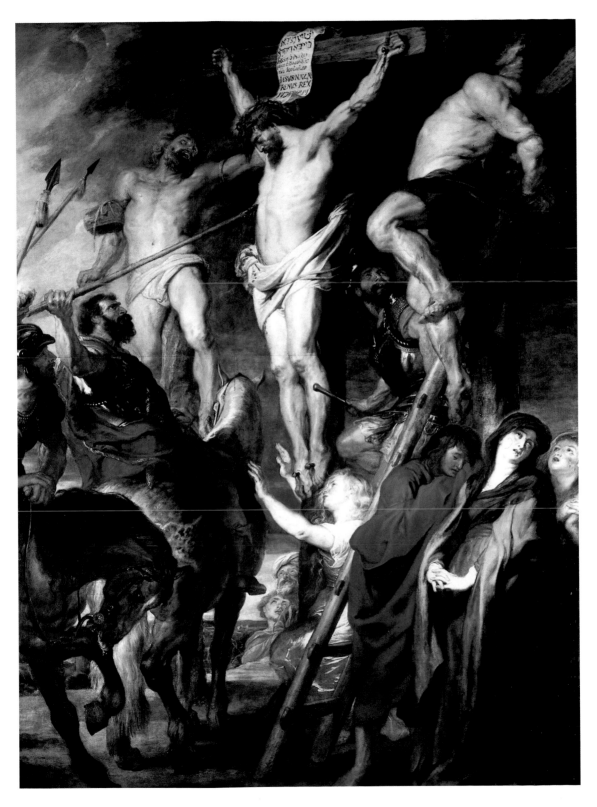

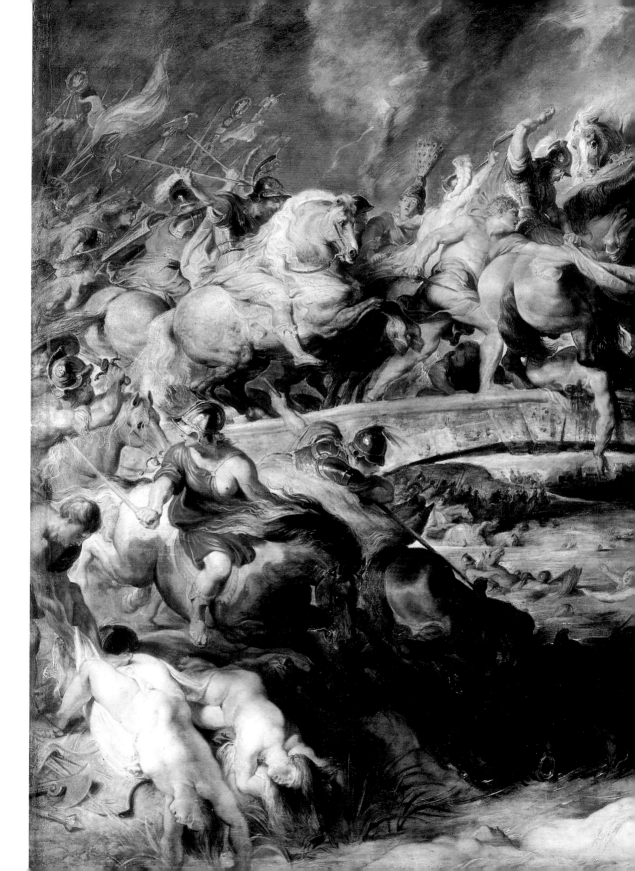

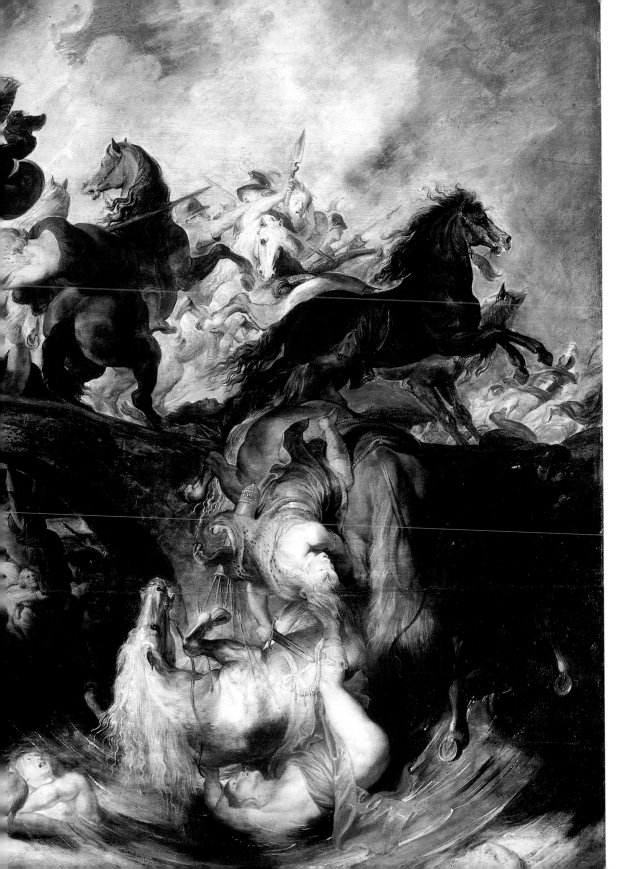

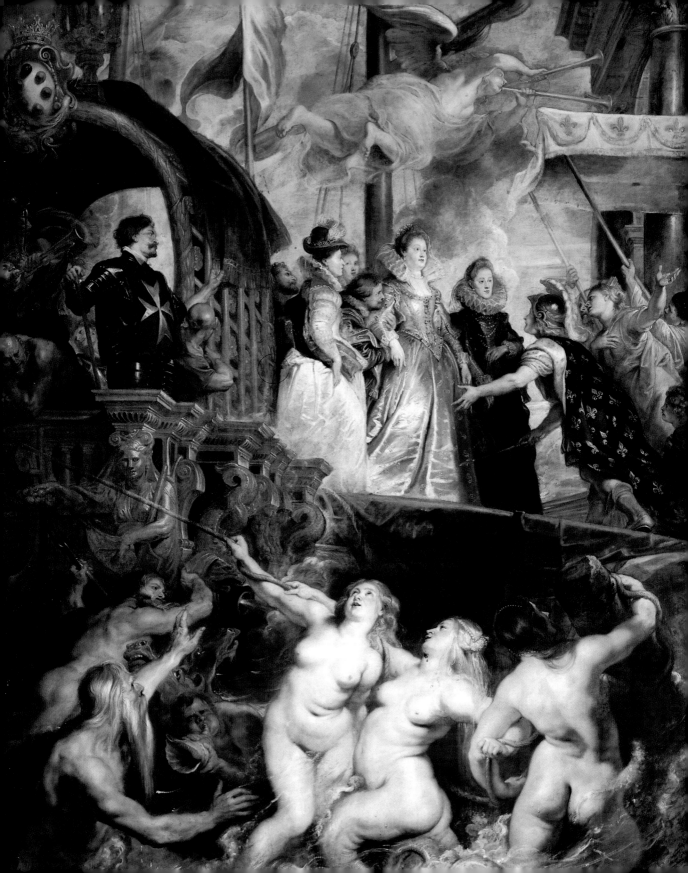

The Studio of Midas
1620–1630

"A Prometheus Bound on Mount Caucasus with an eagle devouring his liver. (Original painted by myself, eagle by Snyders – 1.80 x 2.40 m) … 500 florins

Leopards from nature with satyrs and nymphs (original painted by myself with the exception of a superb landscape by a master landscape-artist – 2.70 x 3.30 m) … 600 florins

A last judgement begun by one of my pupils, after an original painted by myself on a much larger scale for his Serene Highness the Prince of Neuburg, for which I received 3,500 florins in specie as payment; this picture is unfinished, and I shall myself take it in hand, thus making it an original … 1200 florins

A hunt with men on horseback and lions, begun by one of my pupils after an original executed by myself for the His Serene Highness of Bavaria, but entirely retouched by myself … 600 florins."

These descriptions give some idea of the sales catalogue of Rubens' studio in 1620. At the height of his glory, he attracted an influx of commissions so great that no one man could possibly satisfy it. Consequently he set about organising a sort of picture factory to meet demand. This was standard practice at the time. When Otto Sperling, the Danish doctor, visited the studio in 1621, he saw "a large hall without windows, lit only by a large skylight. There were many young painters there, working on different canvases, for each of which Rubens had made chalk drawings, here and there adding indications as to colour. These he later finished himself, and they then passed for works by Rubens." This proceeding has, of course, presented art historians with inextricable problems. But, as we have seen, Rubens did not mislead his customers; he specified who had worked on what, and adjusted prices to reflect the degree of his own involvement. His collaborators could, in any case, scarcely be described as pupils. He chose them among the best artists of his time, each according to his speciality: one for flowers, another for animals, another again for landscape. They included the landscape artist Jan Wilden and the animal-painters Paul de Vos and Frans Snyders. Snyders' Olympian eagle will forever devour the liver of Rubens' *Prometheus Bound* (p. 19). Certain of his collaborators went on to become famous in their own right; they include Van Dyck and Jordaens (*Prometheus*, p. 19). Both men later brought a wholly new dimension to certain aspects of Rubens' art. The role of the studio has at various times been both exaggerated and understated. But everything leads us to believe that it was at its most active

Louis Beroud: *The Joys of Inundation*, 1910
Oil on canvas, 254 x 189 cm
Private collection
A Belle-Époque *peintre pompier* submerged by the abundant curves he is copying at the Louvre.

PAGE 42:
The Landing of Marie de' Medici at Marseille,
1622–1625
Oil on canvas, 394 x 295 cm
Paris, Musée du Louvre

Peter Paul Rubens and Jan "Velvet" Brueghel:
Allegory of Sight (detail), 1617
Oil on wood, 65 x 109 cm
Madrid, Museo Nacional del Prado

between 1615 and 1625. Nevertheless, the majority of the large compositions are by Rubens' own hand, and the work of his collaborators was constantly monitored and corrected by the master, who directed his assistants' work like a maestro conducting his orchestra. With the artists whom he knew well, works produced in collaboration were more like a duo sonata or aria scored for two voices. One such collaborator was Jan Brueghel the Elder, a colleague of Rubens' Roman years, and also a court painter; his expertise in floral compositions had earned him the nickname "Velvet" Brueghel. Nine years older than Rubens, he was indeed peerless in rendering the detail of fabric and materials with the precision of a miniaturist. From the earliest years of the 17th century, he had captivated Antwerp with his virtuoso flower-paintings. The *Allegory of Sight* (p. 44) gives some idea of these collaborative productions, which were exhibited for sale amidst precious items from Rubens' collections. *The Virgin and Child in a Garland of Flowers and Putti* (p. 45) is a further delicious example of this happy marriage of talents, one much appreciated by collectors. Each exhibits his own virtuosity,

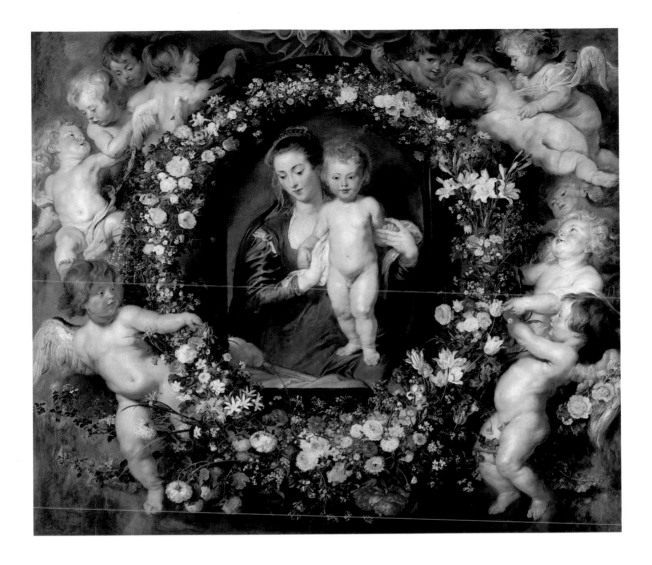

Rubens painting the figures and Brueghel the flowers. The nude among animals and flowers in *Allegory of the Sense of Smell* (p. 47) is another perfect example of the collaboration of these two baroque artists. For Rubens, such co-operative work was born of choice rather than necessity. He was thus able to publicly acknowledge the superiority of Frans Snyders in the representation of dead animals, having implicitly recognised this in *The Head of Medusa* (p. 26), for which Rubens painted only the head of the Gorgon, leaving Snyders to paint the insects, writhing snakes, and background landscape.

The paintings thus produced in the Rubens studios belong to a variety of categories, which one might today compare to the difference between made-to-measure and off-the-peg. First, there were the works painted exclusively by himself. Then there were those executed with the assistance of specialists such as Snyders and Jan Brueghel, artists already fully mature. Finally, there were works that bore his mark but had never seen his hand, the equivalent of Must chez Cartier, as it were. The most remarkable of his assistants was no doubt Anton

Peter Paul Rubens and Jan "Velvet" Brueghel:
The Virgin and Child in a Garland of Flowers and Putti, c. 1620
Oil on wood, 185 x 209.8 cm
Munich, Alte Pinakothek

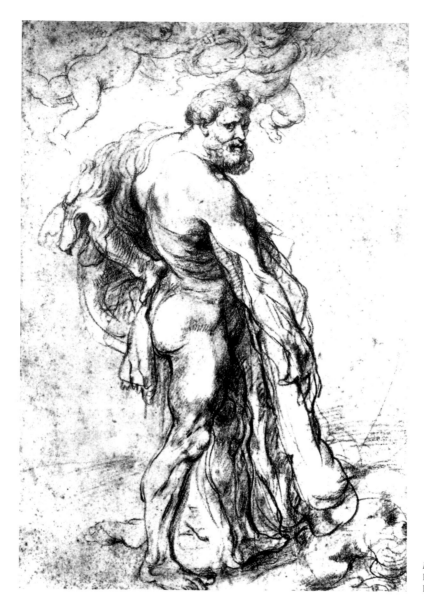

Hercules Crowned by Genii, c. 1621
Drawing, 47 x 32 cm
London, British Museum

Van Dyck, who was twenty-two years younger than his master. Van Dyck entered the studio as a simple apprentice, but was, like his master, both very gifted and very quick on the uptake. He was able to support Rubens in two of the most ambitious projects of the period: his first cycle of tapestries, and a series of thirty-nine ceiling paintings. Van Dyck was a veritable prodigy, and so effectively assimilated the style of his master that their works have often been confused. Thus Van Dyck's *Triumph of Silenus* in the National Gallery, London, closely resembles the *Silenus* painted by Rubens at around the same time (p. 33). Moreover, Rubens himself declared Van Dyck his "finest disciple", and the Jesuits, convinced of this truth, hastened to put Van Dyck to work on the decoration of their churches. Van Dyck in due course made his own fortune, leaving for London

PAGE 47:
Peter Paul Rubens and Jan "Velvet" Brueghel:
Allegory of the Sense of Smell (detail), 1617–1618
Oil on wood, 64 x 109 cm
Madrid, Museo Nacional del Prado

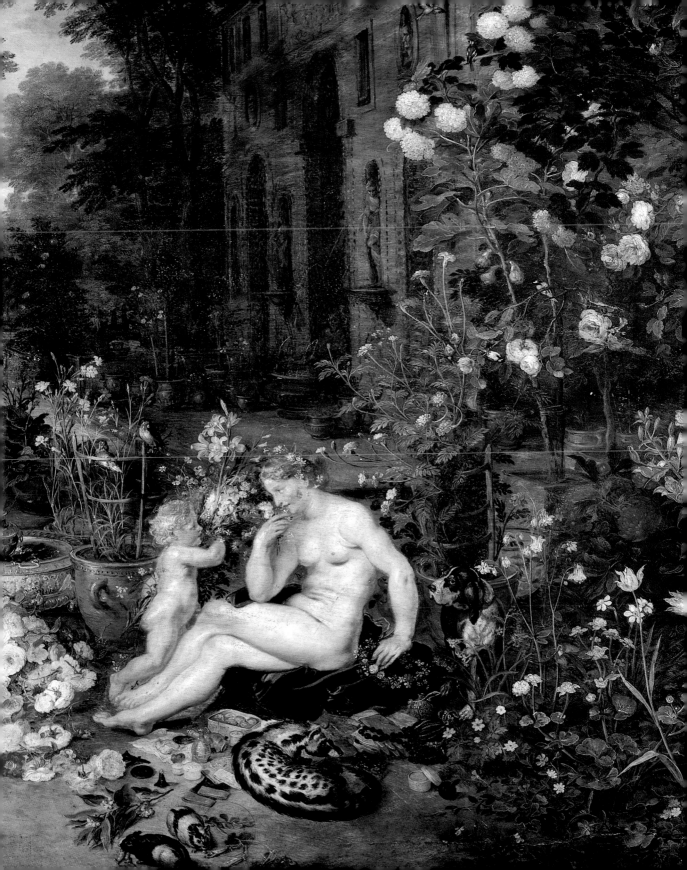

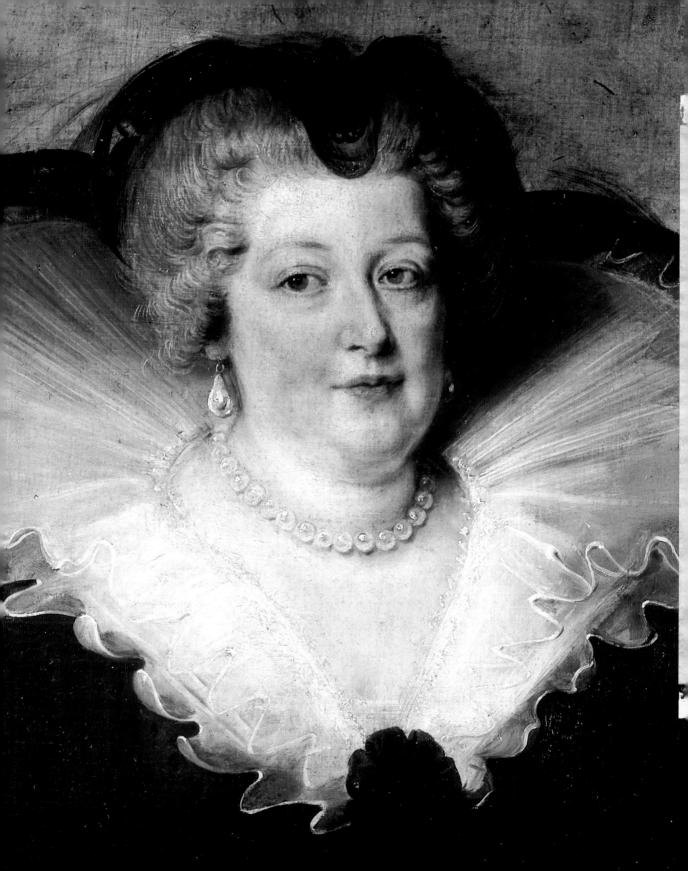

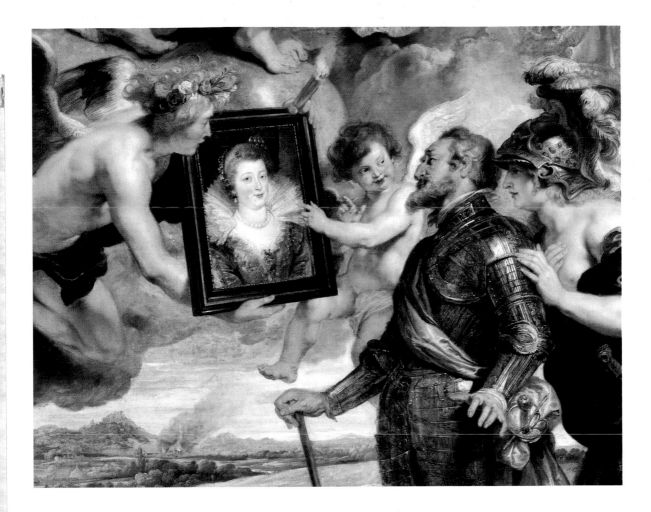

where he became the toast of the English court for his subtle portraits, most notably those of Charles I.

Thanks to his organisational capacities, Rubens could thus meet demand and revolutionise the problem of large-scale pictorial decoration. His renown extended well beyond the frontiers of his country, and in 1621 Marie de' Medici, widow of Henri IV of France and mother of the reigning king Louis XIII, invited him to Paris. She wished him to decorate one of the galleries of the newly built Palais de Luxembourg with 24 monumental paintings commemorating episodes in the lives of herself and her renowned husband. The creation of a cycle of tapestries had, in a sense, been Rubens' technical apprenticeship for this demanding task, the composition of a cycle of vast narrative paintings dedicated to a living queen who had already entered history. Giving epic treatment to this biographical subject, Rubens was also able to give free rein to his fertile invention. He prepared two series of oil sketches, with detailed figures drawn in, which it then fell to his assistants to scale up to the dimensions of the canvases commissioned. These were then meticulously retouched by the master so that they might be ultimately be described, at least in the final layers of paint, as his own works. The abbé de Saint-Ambroise, councillor to the Queen Mother,

Presentation of the Portrait of Marie to Henri
(detail: Henri IV regarding the portrait),
1622–1625
Oil on canvas, 394 x 295 cm
Paris, Musée du Louvre

PAGE 48:
Portrait of Marie de' Medici (detail), 1622
Oil on canvas, 130 x 108 cm
Madrid, Museo Nacional del Prado

49

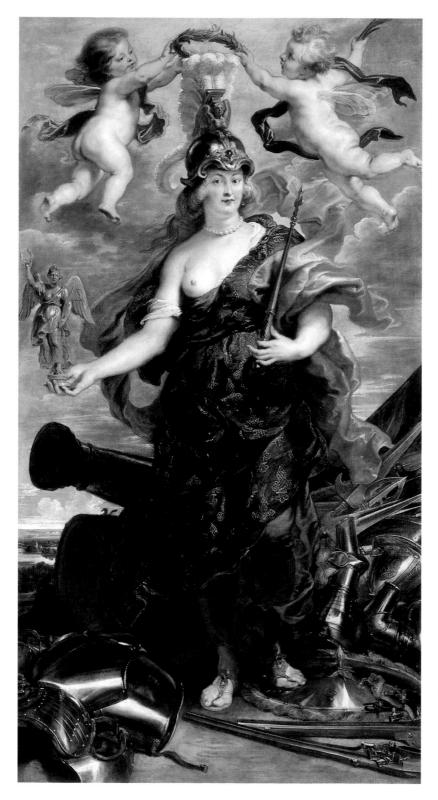

Marie de' Medici as Bellona, 1622–1625
Oil on canvas, 276 x 149 cm
Paris, Musée du Louvre

PAGE 51:
*The Meeting of Marie de' Medici
and Henri IV at Lyon*, 1622–1625
Oil on canvas, 394 x 295 cm
Paris, Musée du Louvre

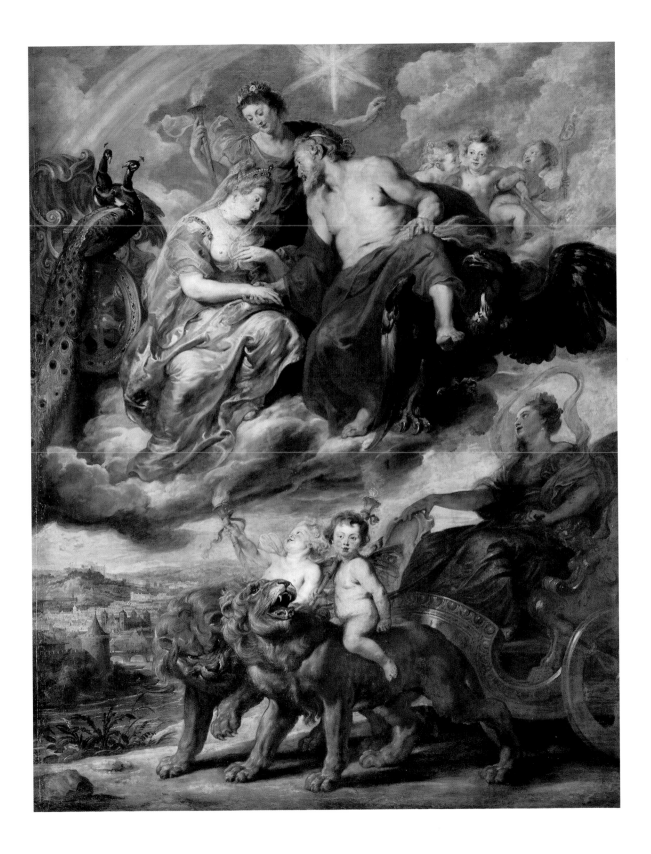

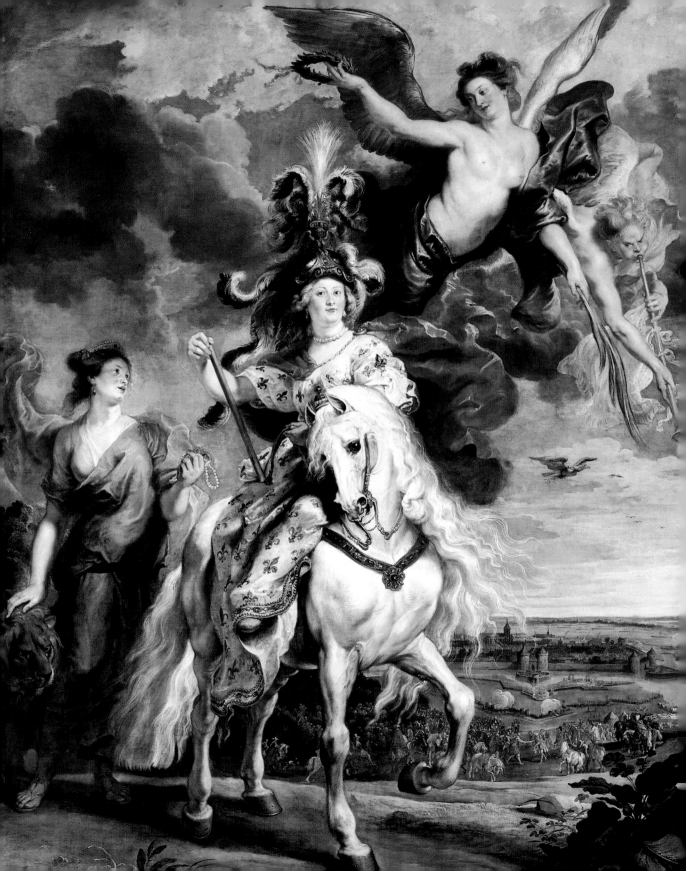

declared in astonishment: "Two Italian painters could not achieve in ten years what Rubens could do in four". In fact, the entire commission was completed in only three years. All of his prodigious culture was drawn on for these works: his encyclopaedic knowledge of classical mythology was exploited to the full in transforming the queen's entire career – Henri slipped rather into the background – into a kind of operatic sequence largely of Ruben's own invention. Metamorphosing life into myth, he freely mingled historical personages with the gods of Olympus, who came to represent them. The scheme of this apparatus was invented as he went along, the – often gratuitous – interpolations of the divine gracefully leavening the uneventful royal life. Confronted with this Rubenesque epic three centuries later, the Goncourt brothers wrote: "They are all descendants of this father, this vast pioneering figure, Watteau no less than Boucher, and Boucher no less than Chardin. For a century, it is as though painting in France had had no other source, no other school, no other homeland than the Galérie du Luxembourg. There the god is lodged." Delacroix waxed lyrical: "His principal quality … is the astounding way in which his figures stand out from the canvas, in short, his astounding life-likeness … Next to him, Titian and Veronese are flat." And it had indeed required all of Rubens' imaginative resources and natural verve to ennoble and illustrate the relatively colourless circumstances of the Queen Mother's life. These qualities were essential; Rubens' international renown depended on his success in this formidable commission. His solution was to populate his compositions with nude goddesses, pagan gods, curvaceous undines, mischievous tritons, and genii unspecified. His customary contrasts are at work in the playful opposition of gleaming cuirasses and lusty bodies, fragile silks and the rugged hulls of dreadnoughts. Here too are collocated warm and cold, glitter and grisaille. "My talent is such," he declared, as he set about this commission, "that no enterprise, however grand and complicated, could ever daunt my confidence". And his improvisatory genius won the day. Even at his most audacious, Rubens imparted to his colours a wonderful fluidity; their transitions are easy and harmonious, and the play of form is at once uninhibited and irresistible. This is Baroque opera at its best. Only the sounds are lacking. The poverty of his subject – in which Rubens placed little stock – was utterly transcended; this is pure painting, nothing but painting. And its use of colour may be said to have anticipated the experiments of Impressionism. The American Romantic painter, Washington Alliston, said admiringly of the Medici Cycle: "Rubens was a liar, a splendid liar, I admit; but I prefer to lie like Rubens than to tell the truth in the miserable servile manner of certain painters". Certainly, it was not the rather heavy features of the Medici family, particularly evident in the queen, that had attracted Henri IV, but the scale of her dowry. Rubens nevertheless contrived to render her portrait agreeable (pp. 48–49). He disguised her now as an attractive *Bellona* (p. 50), now as a proud horsewoman in *The Capture of Juliers* (p. 52). The royal couple become Olympian deities in *The Meeting of Marie de' Médicis and Henri IV at Lyon* (p. 51), while *The Fate Spinning Marie's Destiny* (p. 53) and *The Triumph of Truth* (p. 54) became pretexts for a proliferation of female convexity.

Though the cycle was an artistic triumph, it was something of a political and financial fiasco. Rubens had to work very hard to secure payment for his labours. He made a huge loss on the business, describing it as *dannosissima* ("thoroughly deleterious"). The decoration commissioned by the Queen Mother was repellent to her son, Louis XIII, a cold rationalist who found little to admire in the allegorical exuberance of Rubens' Baroque invention. Moreover, the diplomatic activity

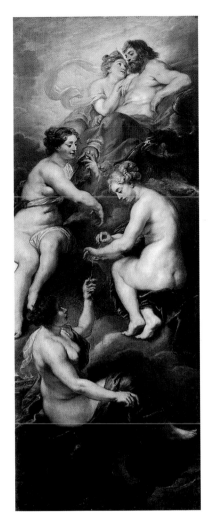

The Fate Spinning Marie's Destiny, 1622–1625
Oil on canvas, 394 x 153 cm
Paris, Musée du Louvre

PAGE 52:
The Capture of Juliers, 1622–1625
Oil on canvas, 394 x 295 cm
Paris, Musée du Louvre

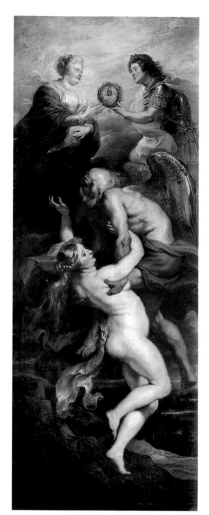

The Triumph of Truth, 1622–1625
Oil on canvas, 394 x 160 cm
Paris, Musée du Louvre

PAGE 55:
Portrait of Anne of Austria (wife of Louis XIII),
1621–1625
Oil on canvas, 85 x 37 cm
Paris, Musée du Louvre (work of Rubens' atelier)

of the painter, which persisted throughout his epic venture, ran counter to the policies of Richelieu, and the king could not condone this. He considered Rubens a spy in his own court. He nonetheless commissioned his own portrait and that of his wife, *Anne of Austria* (p. 55), along with a series of sketches and large cartoons of the story of Constantine. Rubens the diplomat-artist responded with rigorously classical portraits, from which every trace of Baroque invention was meticulously excluded. The mother of the future Sun King, Louis XIV, was portrayed in all her feminine majesty. Documentary evidence suggests that the Constantine tapestries were a speculative operation jointly conducted by Rubens and the Parisian manufacturers, who counted on the former's entrepreneurial talents; he was to put the idea forward, and the series was to be sold to Louis XIII. So flattering a theme – the history of the first Christian emperor – would surely tempt the young king? But Rubens' celebration of the Queen Mother proved so overwhelming a success that the tapestries and their allegory were overshadowed, and the vexed king disposed of them before they were so much as finished. In 1625, he presented them to the Papal Legate, and the series was eventually completed by Pietro da Cortona on the looms of the Barberini family. By 1625, Rubens had felt which way the wind was blowing, and wrote to his friend Peiresc: "In short, I am weary of this court, and if they do not settle with me promptly, given that I have served the Queen Mother most scrupulously, I may never return (strictly between ourselves)."

The obstinate and vain George Villiers, Duke of Buckingham, did not much impress Rubens either. Villiers was about to set in train a series of major political and military catastrophes. He was, nonetheless, like his monarch Charles I, a great art-connoisseur, and determined that Rubens should paint his equestrian portrait. The handsome air he wears in these portraits did not reflect Rubens' view of the man. "When I think of the caprice and arrogance of Buckingham," he later declared, "I am filled with pity for the young king who, through bad advice, is about to hurl himself and his kingdom into such a terrible plight. It is easy to start a war when one wants, but wars are not so easily ended." The English Civil War followed as if in illustration, and the remark has lost none of its force.

The Constantine tapestries and the Medici Cycle accounted for much of Rubens' time during the years 1622–1625, and were his principal achievements. But he did not therefore refuse other religious or private commissions. Thanks to the famous studio, his "Rubens factory", he could meet such demands by increasing production. Not all the studio works properly reflect his genius; many reflect the less exceptional talents of his assistants, to whom he granted almost complete freedom. He complained meanwhile of being "the busiest and weariest man in the world". We know that there are more than sixteen hundred paintings by Rubens himself, in addition to the hundreds of surviving drawings. If we put aside his voyages and diplomatic activities, that makes one work every week for thirty-two years. This may seem very productive. But there were weeks in which Rubens painted two or even three works …

Was Rubens avaricious? Was he the mere "tradesman" he has been accused of being? No doubt, given the rewards to be had, the temptation to meet all available demand – at whatever cost to quality – was a real one. But Rubens was perfectly honest about his proceedings. Studio works were rigorously distinguished from those to which he had, to a greater or lesser extent, contributed. Felipe IV of Spain wanted works by Rubens, and he wanted them in quantity; Rubens himself supplied them, and no assistants were permitted to help him. *The Holy Family with St. Anne* (p. 59) shows how tender the master's own hand could be

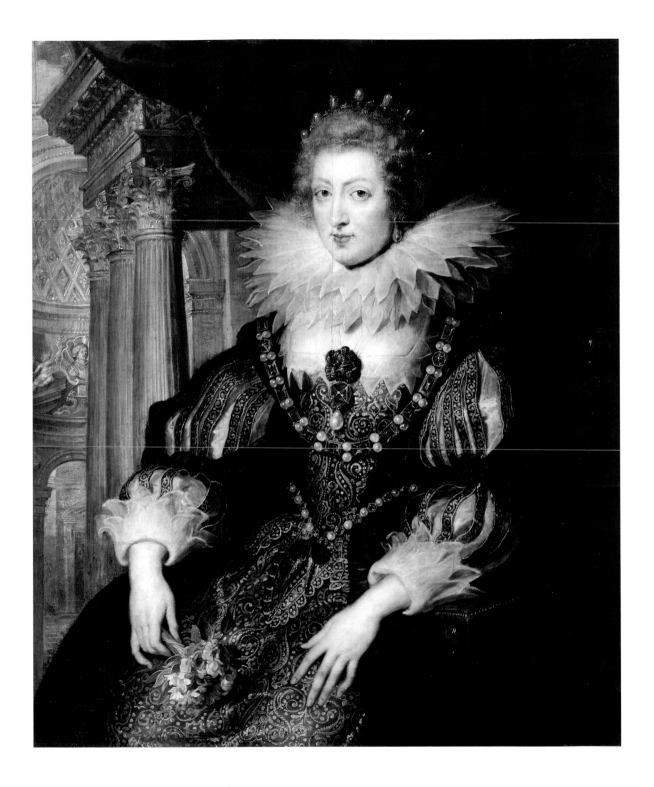

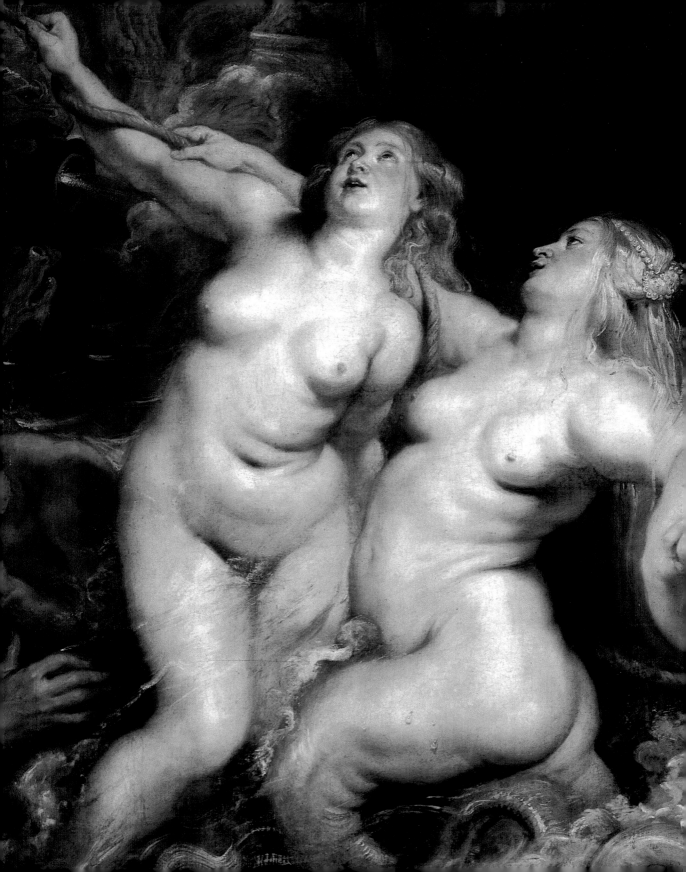

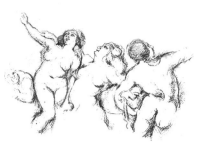

Paul Cézanne: *Naiads, after Rubens*, c. 1880
Pencil, 31 x 45 cm
Private collection

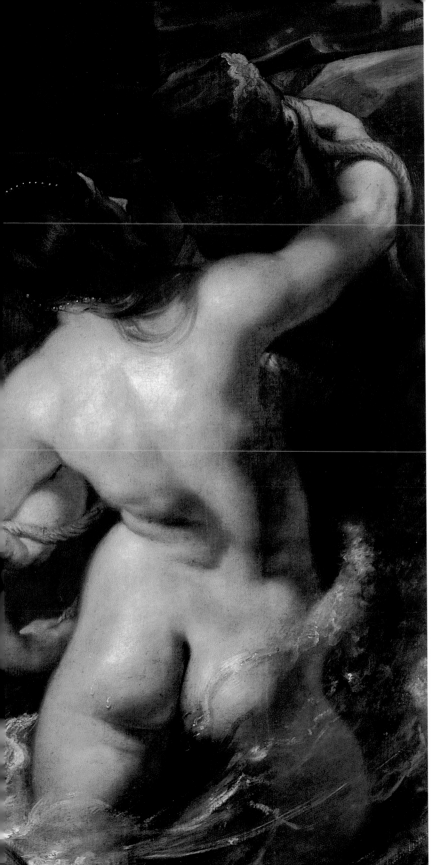

Detail of the Naiads from **The Landing of Marie de' Medici at Marseille** (page 42), 1622–1625
Paris, Musée du Louvre

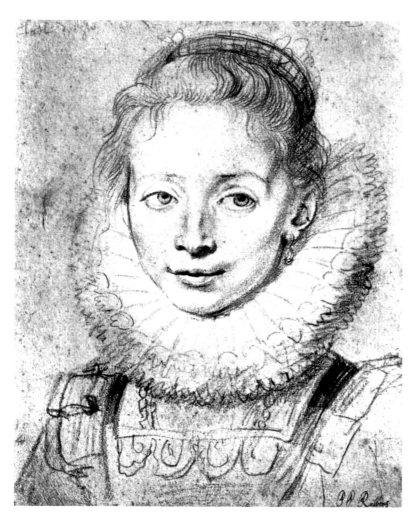

in representing the warmth of family life. The Cardinal-Infante, Fernando, wrote
to Felipe: "Rubens is working zealously on your commissions, but asks that he
not be obliged to do more than he can …". The portraits of his children, mean-
while – of Clara Serena (p. 58), Albert and Nicolaas (p. 61) – are entirely personal.
The same can be said of the little cabinet paintings on panel that Rubens painted
purely for his own pleasure. These were often inspired by his readings. One such
is the picturesque and convoluted narrative of *Angelica and the Hermit* (pp. 62/ 63),
inspired by Ariosto's *Orlando Furioso* (Canto 8, ll. 45 ff.); the beauteous Angelica
has been magically transported to a desert island, where she has fallen prey to an
evil hermit.

This flourishing period in Rubens' life was interrupted, in 1626, by the death
of his wife Isabella Brant. Seeking distraction from his grief, Rubens threw him-
self into important diplomatic missions. He helped to arrange the peace between
England and Spain and negotiated an agreement between the States-General of
Holland and the Southern Provinces of the Netherlands. This did not prevent
him executing numerous commissions in London and Madrid, in particular the
Portrait of Felipe IV of Spain, which so pleased Felipe that he ennobled the artist.

59

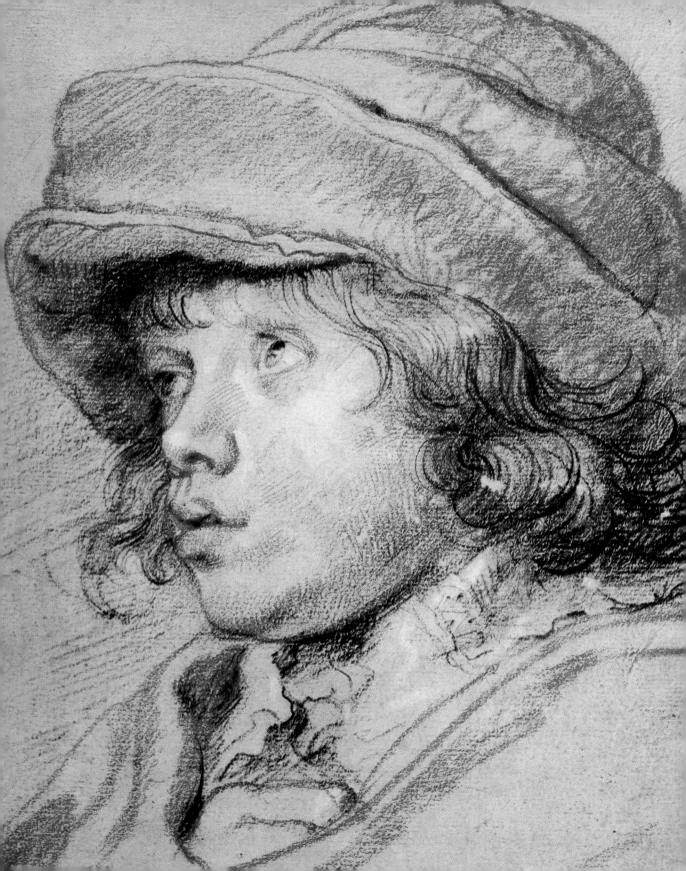

Albert and Nicolaas Rubens, 1626–1627
Oil on wood, 157.4 x 92.7 cm
Vaduz, Sammlungen des Fürsten
von und zu Liechtenstein

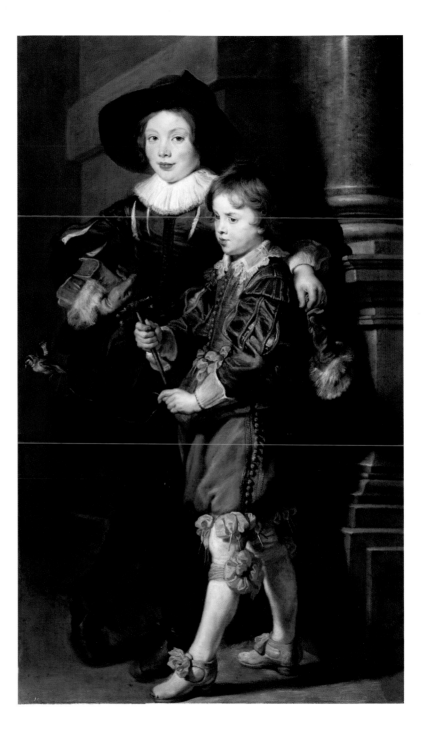

PAGE 60:
Nicolaas Rubens, c. 1625–1626
Drawing, 29 x 23 cm
Vienna, Albertina

PAGE 62/63:
Angelica and the Hermit, 1626–1628
Oil on wood, 43 x 66 cm
Vienna, Kunsthistorisches Museum

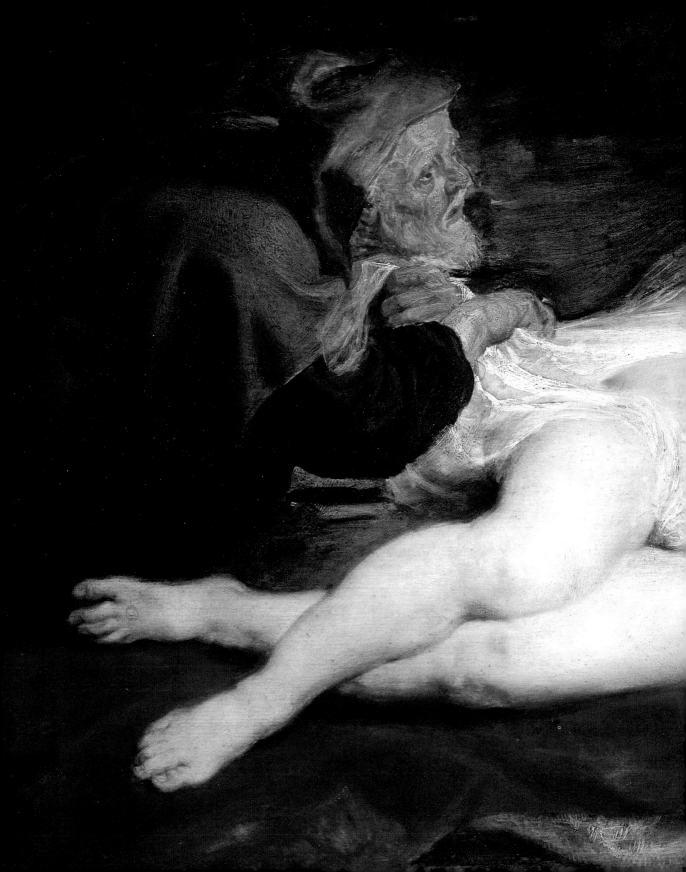

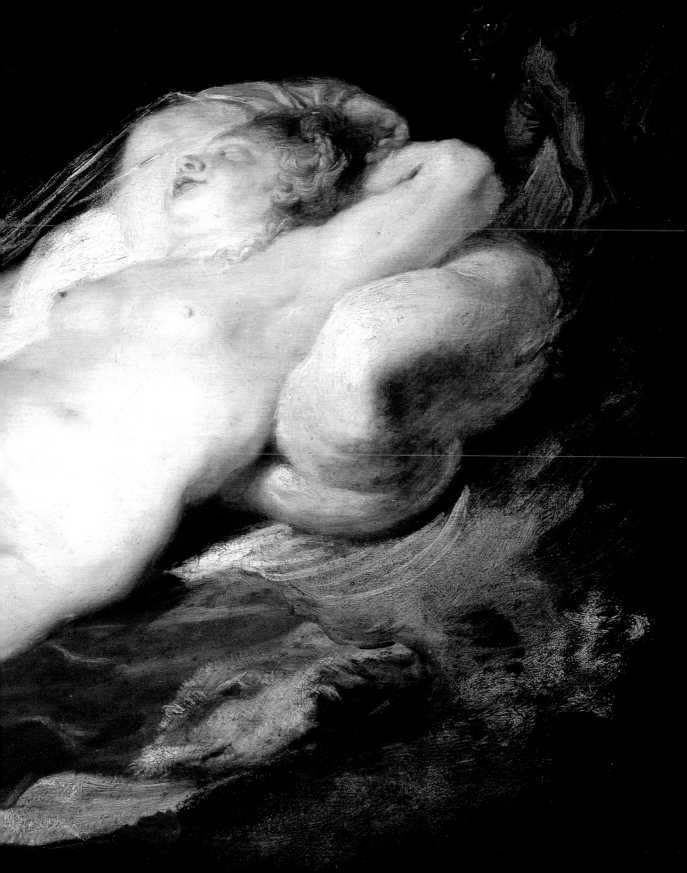

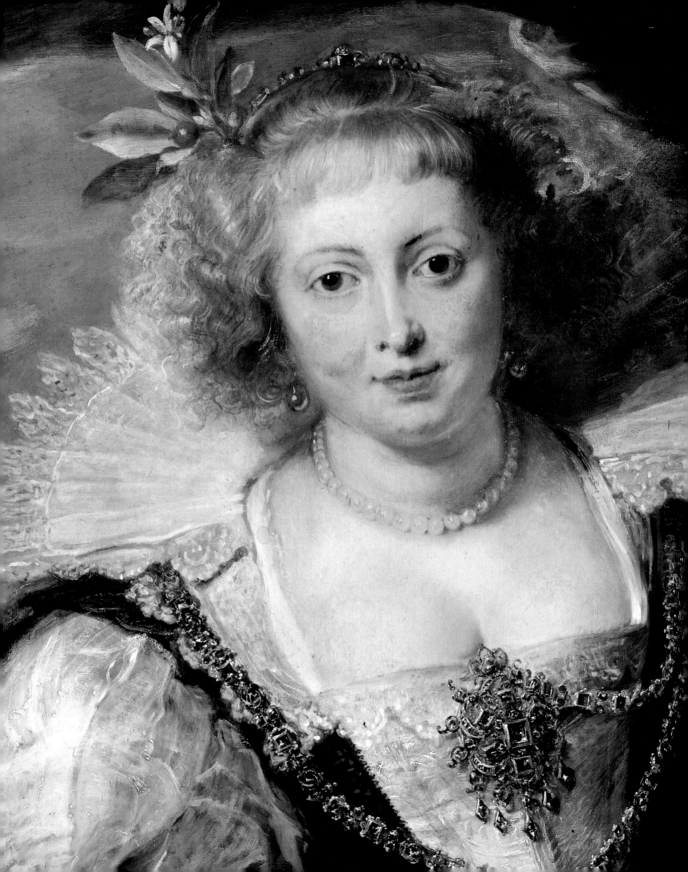

The Most Beautiful Woman in Antwerp
1630–1640

It took nothing less than a Rubens to do justice to the "Helen of Antwerp, who far surpasses the Helen of Troy", and his loving depictions do indeed confirm the words of his old friend, the poet Jan Caspar Gevaerts. He could hardly fail to rise to the comparison, which made of him a Homeric lover while exalting the most disturbing aspects of womanly beauty. Was this Helen an instrument of the demon of lust, an ambush of the senses sent to obsess the painter and diplomat? The historians concur on one point: she was a most intelligent woman, able to give as good as she got, whether her husband spoke of a classical statue, a passage of Tacitus, or a Baroque church. An imposing mind inhabited this imposing body, and for a man of such indefatigable intellectual curiosity, it was not the least of her attractions. When the senses were sated, the mind was still ensnared.

In an attempt to dull the pain of his bereavement, Rubens had accepted both a number of important diplomatic missions and a succession of artistic commissions. At the demand of Charles I of England, who knighted him, he painted the Banqueting House ceiling with a sequence of compositions to the glory of James I. He also painted an *Allegory of Peace* (p. 68) for Charles. It was the pictorial equivalent of the letter he had sent to Peiresc: "I hope that his Holiness and the King of England, but above all the Good Lord Himself will intervene to smother the flames, which currently threaten to spread across and devastate the whole of Europe." But the diplomat was, in this case, less successful and influential than the painter. The English bypassed him and signed a secret agreement with the French. Vexed, he returned to Antwerp in 1630. His two sons were now twelve and sixteen, and he himself was over fifty. Yet the young woman he was now to marry, Helena Fourment, was no older than his elder son. She was, in the words of the Cardinal-Infante Fernando, "the most beautiful woman in Antwerp". She was the younger daughter of the silk and tapestry-merchant, Daniel Fourment, and sister to the Suzanne Fourment whose delightful portrait Rubens had painted some years before (p. 2). Rubens explained himself to Peiresc: "I decided to remarry, for I have never been attracted to the abstinent life of the celibate, and I told myself that, though we should award the crown to continence, we may nevertheless enjoy legitimate pleasures and give thanks for them. I have chosen a young woman of good but bourgeois family, though everyone sought to convince me to make a court marriage. But I was fearful of a vice inbred in the nobility, and especially prevalent among noble women: vanity. So I chose someone

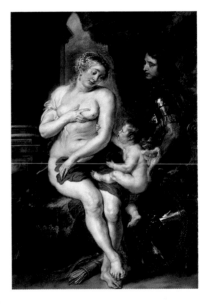

Mars, Venus, Amor, c. 1630
Oil on canvas, 195 x 133 cm
London, Dulwich College Picture Gallery

PAGE 64:
Helena Fourment in Wedding Dress (detail),
1630–1631
Oil on wood, 163.5 x 136.9 cm
Munich, Alte Pinakothek

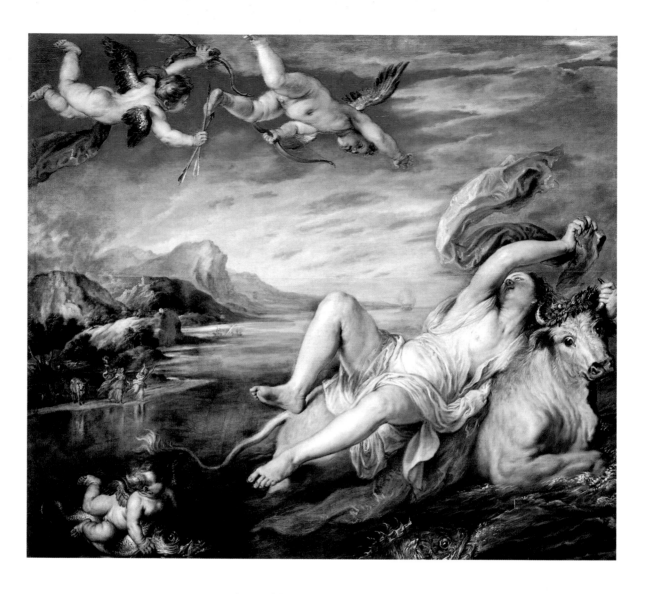

The Rape of Europe, after Titian, c. 1630
Oil on canvas, 181 x 200 cm
Madrid, Museo Nacional del Prado

PAGE 67:
Helena Fourment, 1630–1632
Oil on canvas, 96.6 x 69.3 cm
Munich, Alte Pinakothek

who would never have to blush at finding me brush in hand. And the truth is, I am too fond of my freedom to exchange it for the embraces of an old woman." Far from blushing, Helena was to inspire some of the most personal and moving of all Rubens' portraits.

Inspired by his young love, Rubens' painting now rose to new heights. He and Helena had four children, on whom he doted, and whom he painted many times over. His new happiness found expression in *The Garden of Love* (p. 77), and, in 1635, he gave up diplomacy to devote himself to the country life. He explained the failure of certain negotiations with the observation, "I am a man of peace". He nevertheless continued to accept numerous commissions, drawing the oil sketches from which his assistants completed each work. Religious subjects were displaced by mythological and Dionysiac subjects that he could populate with the buxom and nacreous nudes so closely identified with his art. Above all, he kept constant company with his beloved wife, his "sweet sixteen", whom he

66

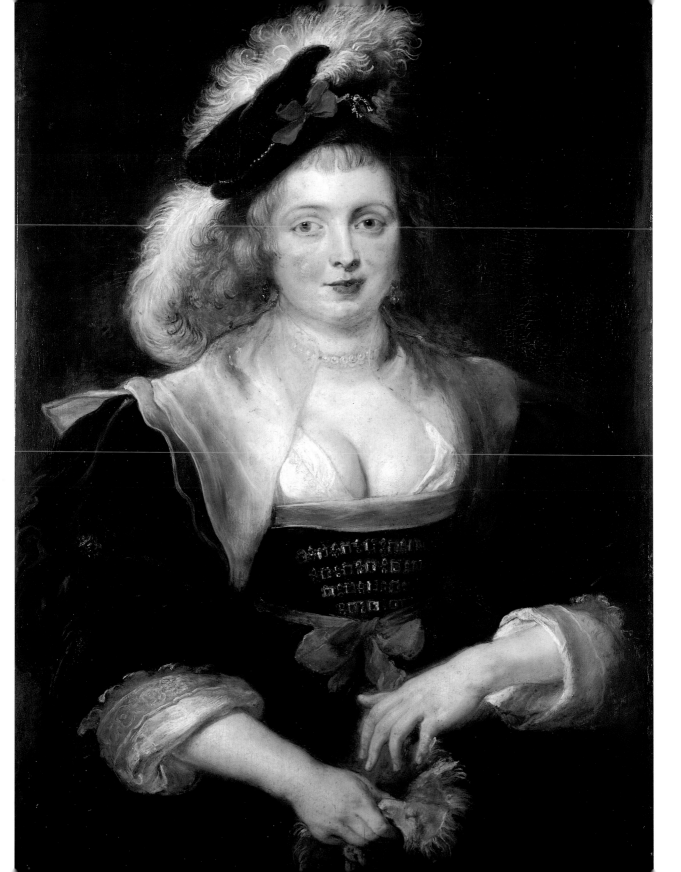

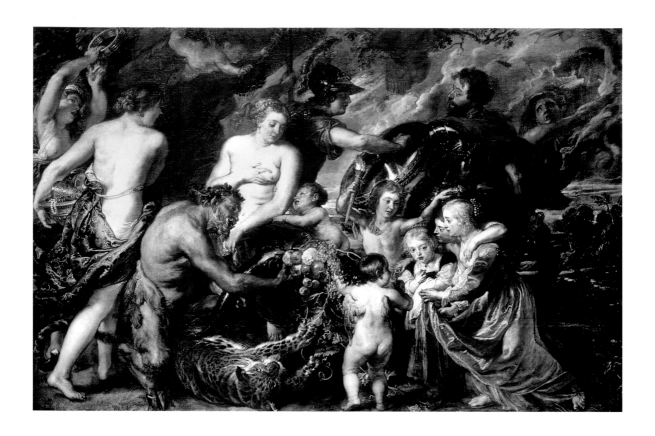

Allegory of Peace, 1629–1630
Oil on canvas, 203.5 x 298 cm
London, The National Gallery

depicted now as a shy doe, now as a devoted odalisque. Were these triumphs earned by her sexual prowess? Was she the legendary child-woman, the Lolita-dream of frustrated middle age? Or the pretty girl whom he dressed and undressed at will, portraying her in *Het Pelsken* (p. 86) nude but for a fur? It perfectly sets off the pale sheen of her skin. Thus the man and the painter made of her what he wished. At all events, he refused to part with *Het Pelsken*, which was certainly his favourite among the many paintings exhibiting her undeniable charms. In tones worthy of Titian, he painted Helena with curly hair, her nipples erect, her nudity barely concealed by a fur wrap better suited to her husband's bulk than her own. Her expression is difficult to read: is her mutinous air intended as a provocation, or was she simply anxious to wrap herself up against the cold? When Sacher-Masoch wrote his most famous work, the *Venus in Furs*, he did so beneath a reproduction of this painting. But Hélène did not humiliate her husband; on the contrary, she protected him from boredom and routine, from mediocre and uneventful happiness. She knew, before Baudelaire's *Les Bijoux* could instruct her, how to entice Rubens' gaze by adorning her nakedness with sonorous jewels. She also knew how to dialogue with the painter. And he transposed their passionate love into portraits, the perfect harmony of their bodies registered in his caressing brush-strokes.

Yet Rubens, for all his influence over the school of Géricault and Delacroix, was anything but a Romantic. His paintings are no idle reflections of the passing mood. His was the high courtesy of a grandee, and the moments most precious to him are reflected in an art at once discreet and poetic. While commercial

production continued apace in the studio, he reserved his strength for the intimate works that lay closest to his heart, and in particular to those that his young wife continuously inspired. Here his painting becomes deeply moving. There are no greater works in his catalogue than the portrait *Helena Fourment with her Children* (p. 83), in which she is seen rosy-complexioned beneath a wide-brimmed feather hat that sets off her round cheeks, or *Helena Fourment on the Terrace with her Eldest Son, Frans* (p. 82). These intensely personal works reveal to us the true Rubens, whose mastery of stroke and palette can convey the sweetness and freshness of youth with incomparable mastery. These brushstrokes, so tenderly applied, reflect an obsession with the beauty of his "Helen".

And so, with tireless enthusiasm, Rubens projected her face into his profane compositions. The world of classical mythology, with its Olympian gods, its nymphs and shepherdesses and superlatively beautiful heroines, became her second habitat. Venus is the deity who presides over the later mythological works of Rubens, and Rubens' Venus was none other than Helena. Late in life, Rubens made a whole series of copies of Titian – see his *Rape of Europa* after Titian (p. 66) – and when he came to reinterpret Ovid, he did so in the light of the earlier master. In *Venus and Adonis* (p. 69), Helen was again his Venus. The painting

PAGE 70/71:
The Festival of Venus Verticordia, 1636–1638
Oil on canvas, 217 x 350 cm
Vienna, Kunsthistorisches Museum

Venus and Adonis, 1635–1638
Oil on canvas, 197.5 x 242.9 cm
New York, The Metropolitan Museum of Art.
Gift of Harry Payne Bingham, 1937.

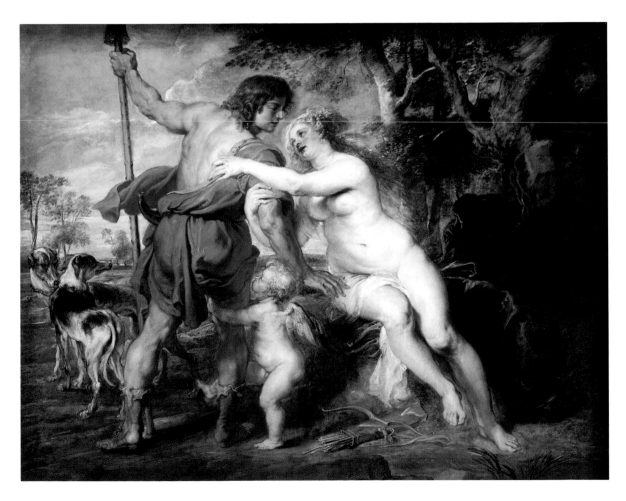

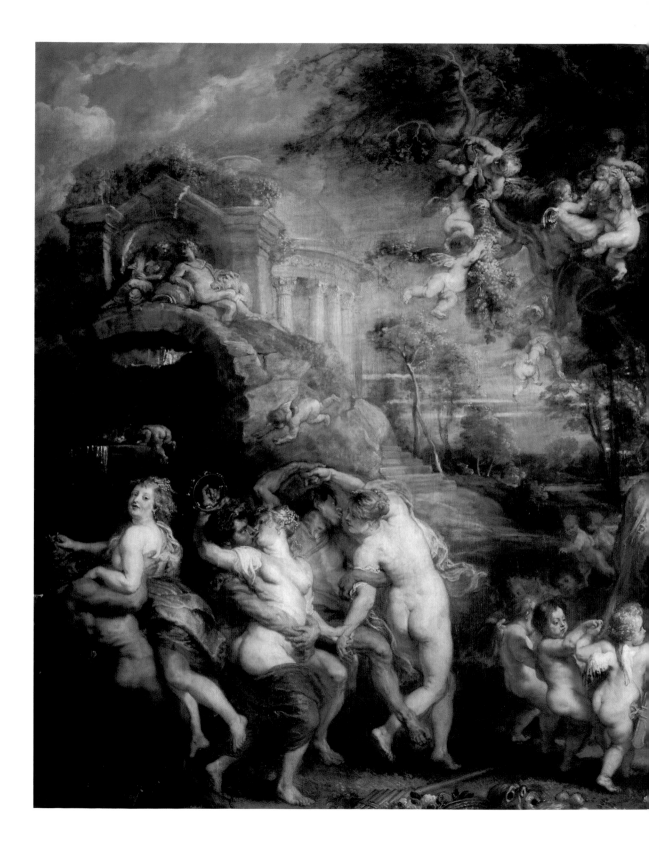

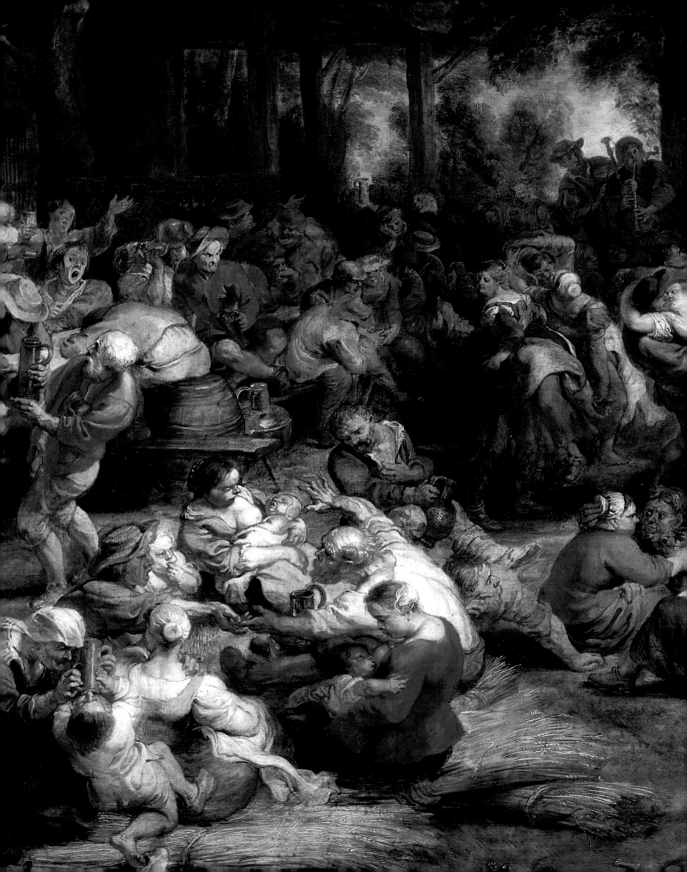

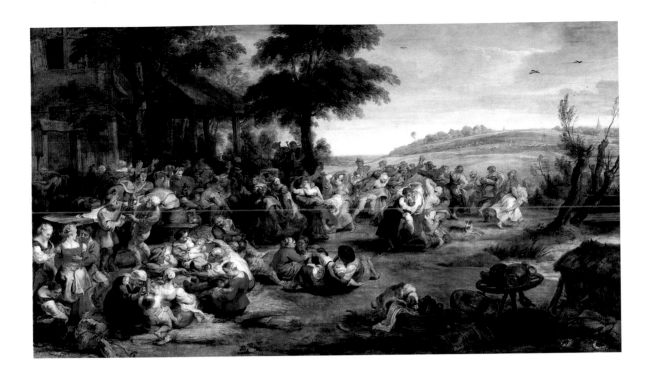

Flemish Kermis, c. 1635–1638
Oil on wood, 149 x 261 cm
Paris, Musée du Louvre

in the Metropolitan Museum of Art, illustrates the lovers' parting: Venus vainly seeks to dissuade the young hunter from his fatal pursuit. There was a Rubens copy of this work, now lost; what survives is his variation on a painting by the master he most revered. The scene created by Ovid in his *Metamorphoses* (Book X) might have been designed for Rubens. In Golding's translation, the story begins when "the armèd Cupid kissed Dame Venus, unbeware/ An arrow sticking out did raze her breast upon the bare". She falls in love, and, fascinated by Adonis's beauty, "Yea, even from heaven she did abstain. She loved Adonis more/ Than heaven". Though she sometimes shared with him the pleasures of the chase, she besought him to avoid the fiercer animals, "For fear thy rashness hurt thyself and work the woe of me". Adonis ignored her pleas, and was killed by a boar. The despairing Venus, sensing his death, discovered his torn body and transformed him: "In a flower thy blood I will bestow". But the flower, like their love, is brief, as Ovid says: "… the winds, that all things pierce, with every little blast/ Do shake them off and shed them so that they cannot last". In Rubens' painting, Venus became the goddess by whom he himself now steered, Helena, while the fate of Adonis is implicit in the painting's elegiac tone. The nude Venus, gracefully seated, begs Adonis to remain, gently coaxing the garment from his shoulder. She casts a beseeching glance at him, her anxiety translated in the disorder of her blonde tresses. The tanned and muscular Adonis is clothed in a dazzling red tunic prefiguring the flower that he is to become; he is the incarnation of a Greek statue, his body standing out against the luminous sky that Venus has abandoned for love of him. At his feet, a little Cupid pleadingly clasps one of his thighs; the presence of the god of love and his quiver evokes the first cause of this tragic encounter. But for the duration of the moment, it is love rather than tragedy that prevails. Thus Rubens transforms the *Metamorphoses* themselves into a symbol of marital love.

PAGE 72:
Detail of *Flemish Kermis*, c. 1635–1638
Paris, Musée du Louvre

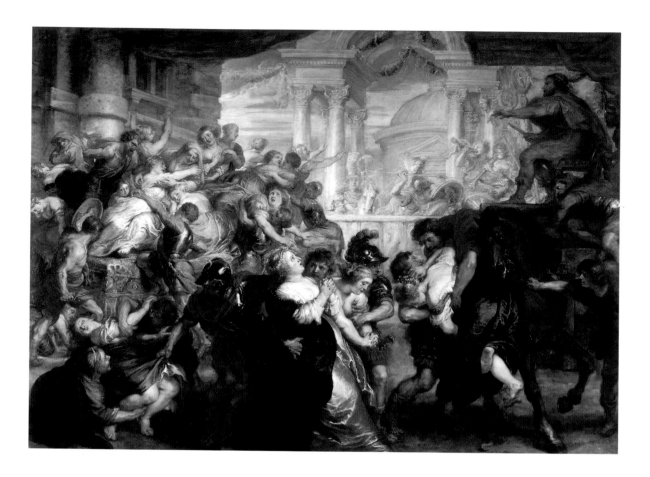

The Rape of the Sabine Women, 1635–1637
Oil on wood, 170 x 236 cm
London, The National Gallery

PAGE 75:
The Horrors of War (detail), c. 1637–1638
Oil on canvas, 206 x 342 cm
Florence, Palazzo Pitti

There is a further starring role for Helena in *The Festival of Venus Verticorda* (pp. 70/71), a highly inventive work, in which she presides over the loving couples assembling here as they would again, a century later, in Watteau's *fêtes galantes*. The work is Rubens' tribute to the Classical Antiquity he so admired and to Titian, whose *Adoration of Venus* it evokes. In the background is a classical temple, while in the foreground, around the votive statue of Helena-Venus, a dazzling bacchanal unfolds; this is one of Rubens' most uninhibited celebrations of the pagan spirit. And it is Helena who is seen from every angle in *The Three Graces* (p. 89) and *The Judgement of Paris* (p. 88 and pp. 90/91), in which she successively embodies Venus, Minerva and Juno. (This is indeed a quandary for Paris.) Renoir was to follow in Rubens' footsteps, depicting himself as Paris in his *Judgement of Paris*, and painting his favourite model Gabrielle in the role of Venus.

There is infinite serenity in these later works of Rubens. The figures are set in an idyllic landscape bathed in light. Everything about them testifies to the relaxed and profoundly happy life that he now led, freed of the burden of diplomacy, and devoted only to his family and art. In Rubens' universe, populated by the Greco-Latin mythology of gods and goddesses, and traversed by Jesus and his Saints, the figure of womanhood in all its splendour was identified with fertility. His Venuses, like his Saints and his Graces, are broad and shapely vessels of maternity. Rubens set these hymns of praise to the principle of life against

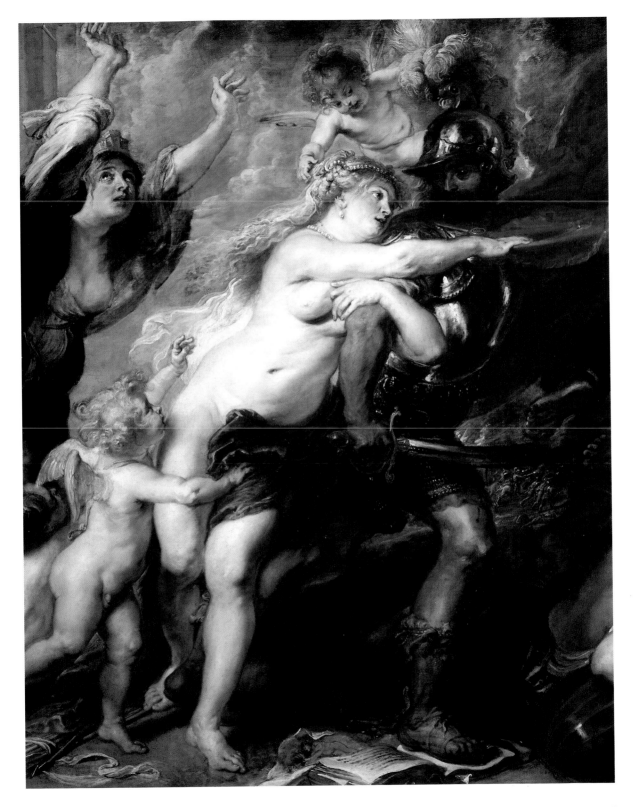

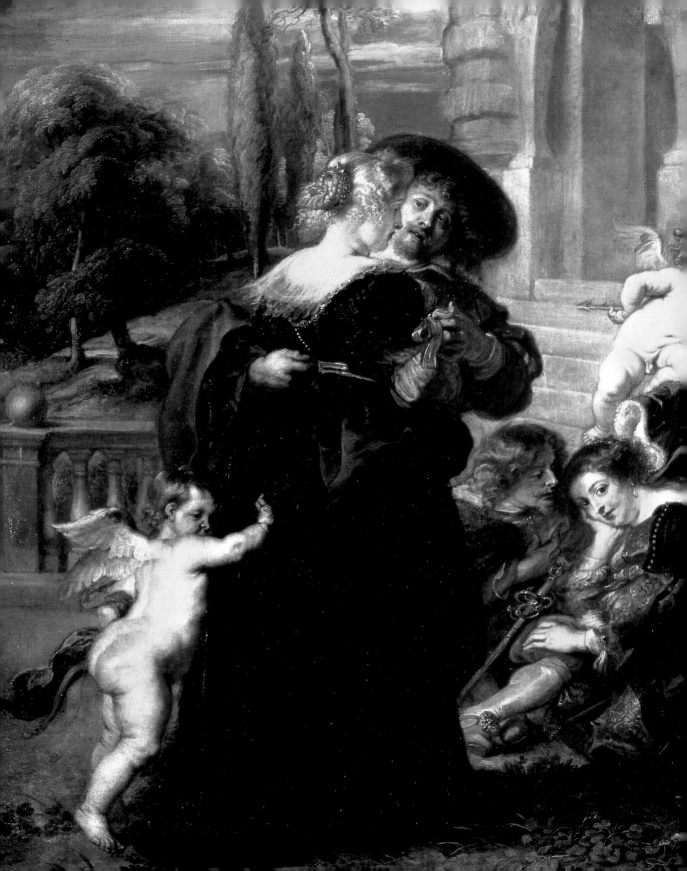

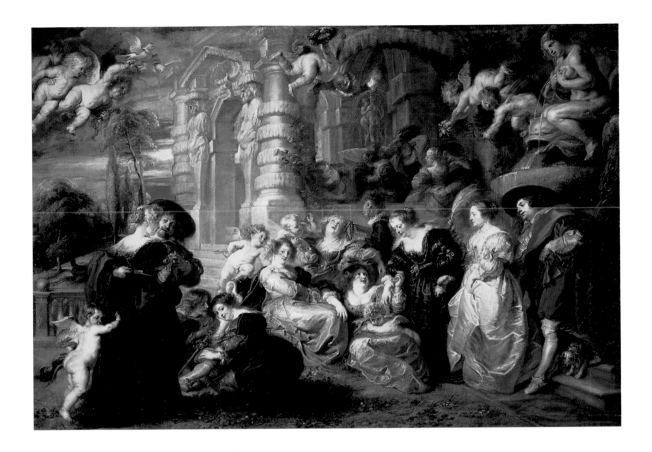

the massacres perpetrated during the wars of religion, which he also recorded in works like the *Allegory of Peace* (p. 68) and *The Horrors of War* (detail p. 75). It is as if he were proclaiming, with the hippy movement of the 1960s, "Make love not war". In answer to the horror and misery of war, he offers the pleasures of Paradise: gardens of love, the bower and the idyll, the dance of the Graces. These sublime effusions were never seen outside the studio, but, acquired by the Spanish throne after Rubens' death, have become the pride and joy of the Prado. They represent the culminating point of Rubens' visionary genius, his most unconstrained and imaginative work, holding in them the seeds of the innumerable masterpieces that they inspired. From this source, the whole of 18th-century art flows.

The works of 1630–1640 are indeed remote from reality. They are the paintings of a man whose imagination is wholly unfettered. The gentle and sensual character that we perceive in Rubens' self-portraits (pp. 92–95) remained constant to the end of his life, and he never desisted from his frank celebration of womanly beauty at its most potent and disturbing. His erotic gusto is mimetic in kind; before a naked woman, he felt neither fear nor embarrassment, merely a powerful appetite for form, colour and light. A vaporous atmosphere surrounds these scenes of festal happiness, poetic masterpieces in which the radiant apparitions offering their nudity as if on the altar of nature are delineated with the surest of touches.

Such interludes might suggest that the "Rubens factory" had ceased production. Nothing could be further from the case. The master had executed a series of

The Garden of Love, c. 1632–1633
Oil on canvas, 198 x 283 cm
Madrid, Museo Nacional del Prado

PAGE 76:
Detail of *The Garden of Love*, c. 1632–1633
Madrid, Museo Nacional del Prado

77

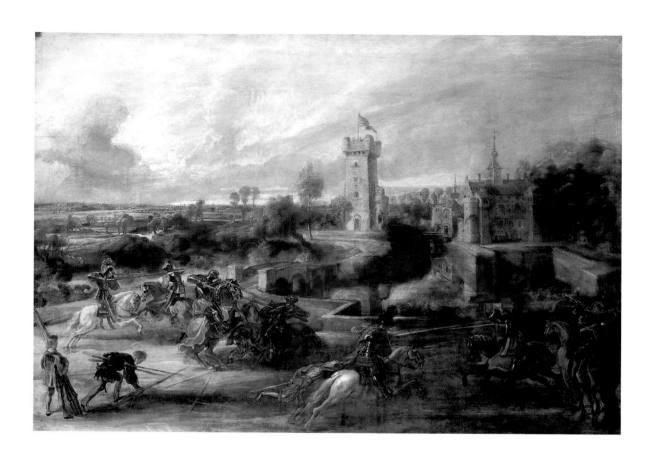

Tournament in front of Castle Steen,
c. 1635–1637
Oil on wood, 72 x 106 cm
Paris, Musée du Louvre

cartoons, and now, one by one, the tapestries of the *Story of Achilles* came into being, surely in response to an order from Rubens' father-in-law, Daniel Fourment. In 1635, the municipality of Antwerp commissioned Rubens to prepare the decoration of the city for the ceremonious entry of the new Governor of the Southern Provinces: Fernando, Cardinal and Crown Prince of Spain. Rubens produced the sketches for 43 triumphal arches, which were then realised by collaborators such as Jordaens, Jan Van der Hoecke, and Theodoor van Thulden. The last-named made engravings of these ephemeral decorations and brought them together in the collection *Pompa Introitus Ferdinandi*. Finally, in 1637–1638, Rubens painted 112 sketches after Ovid's *Metamorphoses*, works commissioned by Felipe IV of Spain for his new hunting pavilion at Torre de la Parada, near Madrid. The paintings themselves were produced by his assistants. It was a commission after Rubens' heart, and indeed, shortly before his death he was working on other mythological and hunting pictures for Felipe's palace in Madrid. Interpretations of Ovid had featured throughout his career. Towards the end of his life, *Metamorphoses* in hand, he turned with renewed enthusiasm to these stories of passion and conflict between mortal and Olympian.

He was now spending the summer months in his country residence, Het Steen, at Elewijt, between Mechelen and Brussels, which he had acquired in August of 1634. There he painted the largest and most luminous landscapes of his entire career; *Landscape with Rainbow* (pp. 80/81) and *Tournament in front of Castle Steen* (p. 78), the latter featuring a wholly imaginary joust. They show us complemen-

tary views of a countryside pullulating with human, animal and plant life. They are odes in paint to the natural order of creation, an Arcadian vision of man living in harmony with nature. At Het Steen, Rubens enjoyed the fruits of his long and industrious career, but he also added a new facet to his reputation and ensured his historical influence as a landscape painter. We might cite, in particular, the landscapes of Constable. With *Return from the Fields* and the famous *Flemish Kermis* (pp. 72–73), Rubens reinforced his reputation as a Protean artist by showing himself the sole heir of the great Brueghel – whose works he collected. At Het Steen, he was immensely happy, wandered among the trees, discovered his landscape gifts, and anticipated the discoveries of Impressionism. Whereas the landscape artists of his time tended to consider the little figures with which their paintings were studded as mere accessories, to be entrusted for the most part to the diligence of their assistants, Rubens restored man's prominence, and showed him sharing in the seasonal life of nature. Cézanne was not the least of those who learned from Rubens' magisterial example. What he admired was the cohesion between the landscape and the figures it encompasses: Cézanne spoke of seeking to penetrate to the very geology of the landscape, of "marrying the shoulders of the hills to the curves of the women". Renoir, too, could not paint either a landscape without figures or a sea without women bathers. In the Brueghelian *Kermis*, Rubens returned to a traditional Flemish scene, with all its familiar episodes: here the joyful tread of the dancing, there the coarse antics of the drunk (detail p. 72). But the sheer sweep of the painting frees the subject

PAGE 80/81:
Landscape with Rainbow, 1636
Oil on wood, 135.3 x 233.9 cm
London, Wallace Collection

Dance of Italian Villagers, c. 1630
Oil on wood, 73 x 106 cm
Madrid, Museo Nacional del Prado

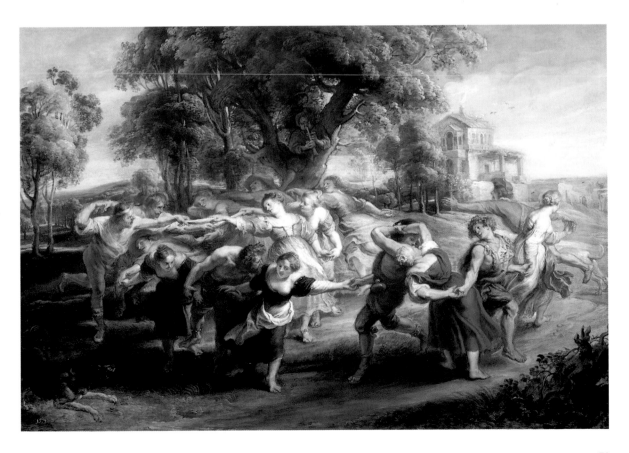

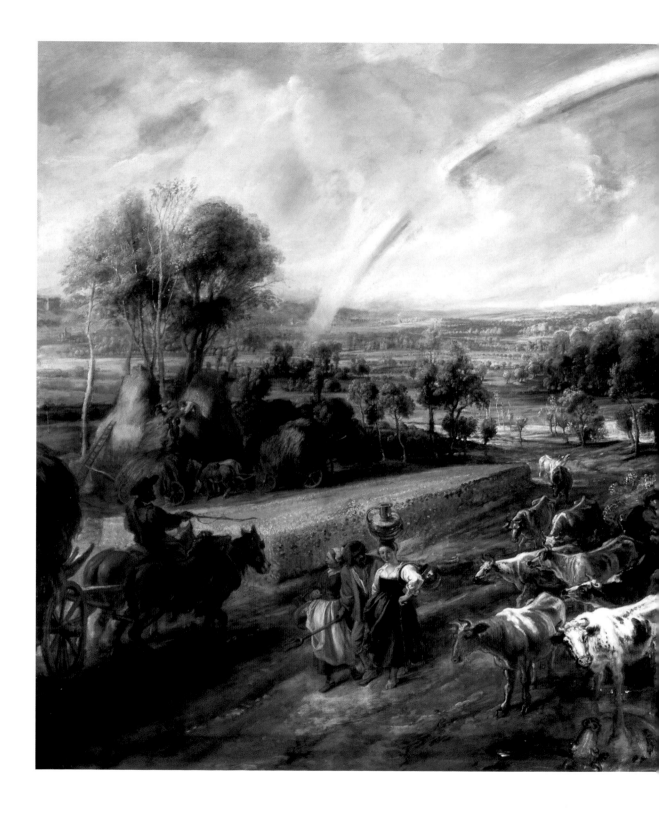

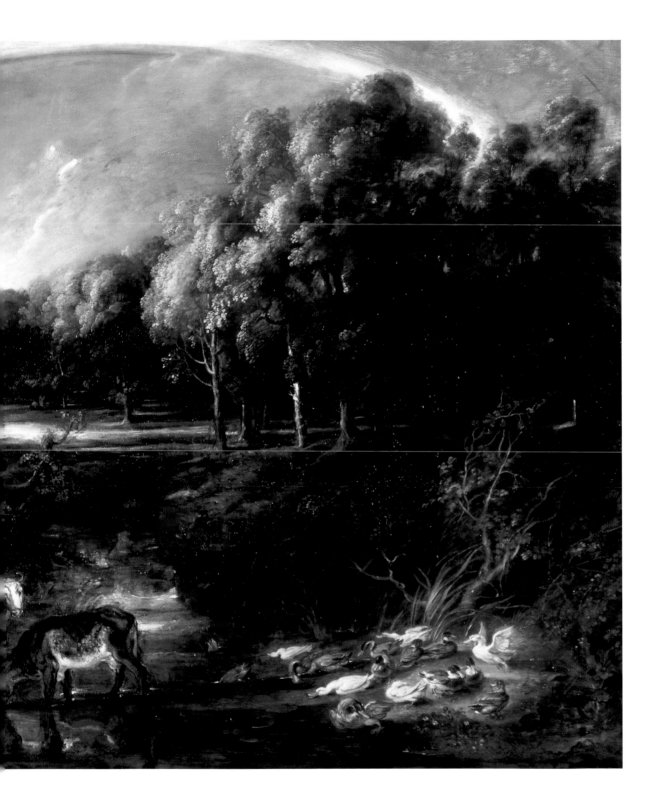

Helena Fourment with her Eldest Son, Frans,
c. 1635
Oil on wood, 146 x 102 cm
Munich, Alte Pinakothek

from its usual tenor of vulgarity and triviality. There is no Naturalism in this painting, rather a kind of ballet whose different scenes unfold beneath the poetry of Rubens' sky. This eternal round, set, like the *Dance of Italian Villagers* (p. 79), against a timeless natural background, shares the merits that inform all Rubens' greatest achievements. Though the treatment suggests a sketch of modest dimensions, the composition somehow attains the monumental, becoming one of his richest and most perfect performances. He invites us to share in the exuberant joy of the Flemish festival, the unbridled pleasure to which the peasant throng abandons itself. The dancing couples reinforce the diagonal of the new-leaved trees in whose shade they twirl and embrace. The swelling and dispersing of the crowd, the figures running, dancing, prancing, capering and pursuing one another are recorded in every attitude and pose imaginable. They sing, shout or

PAGE 83:
*Helena Fourment with her Children, Clara,
Johanna and Frans*, 1636–1637
Oil on wood, 115 x 85 cm
Paris, Musée du Louvre

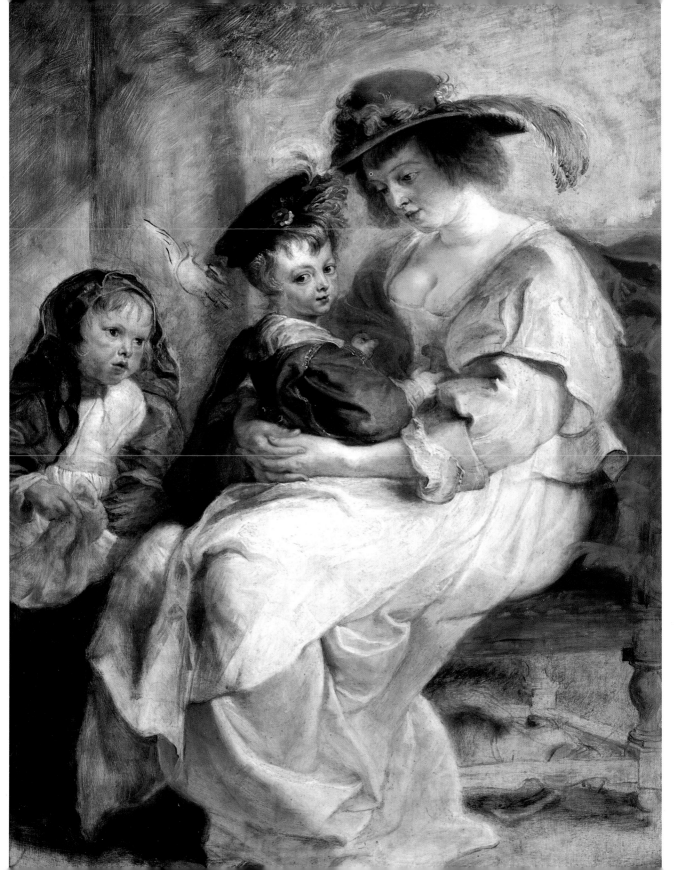

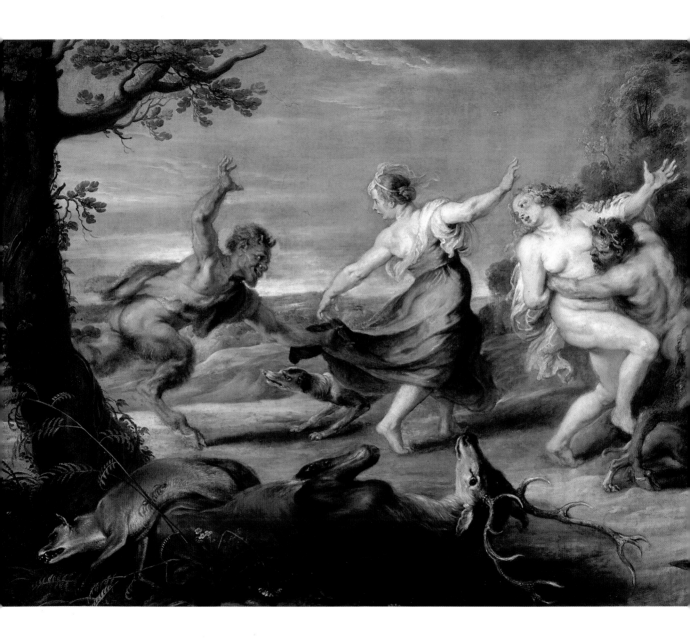

84

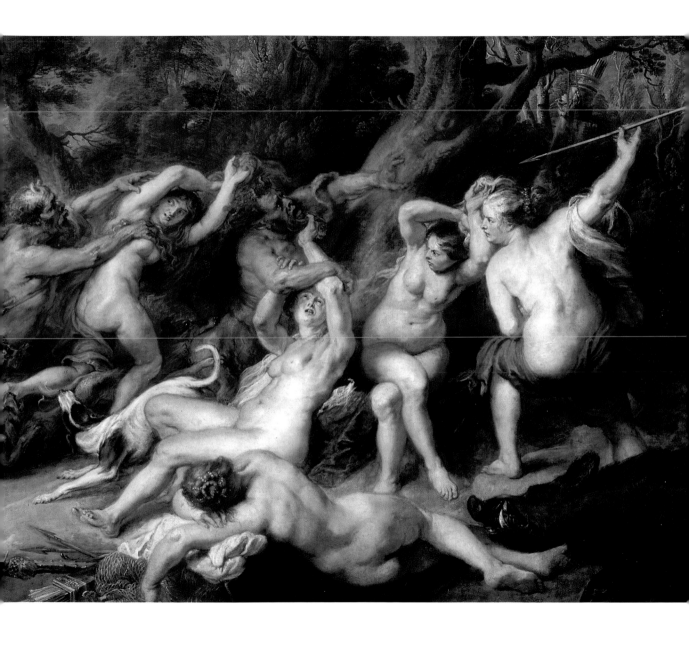

Satyrs and Nymphs (Allegory of Fertility),
1636–1638
Oil on canvas, 136 x 165 cm
Madrid, Museo Nacional del Prado

85

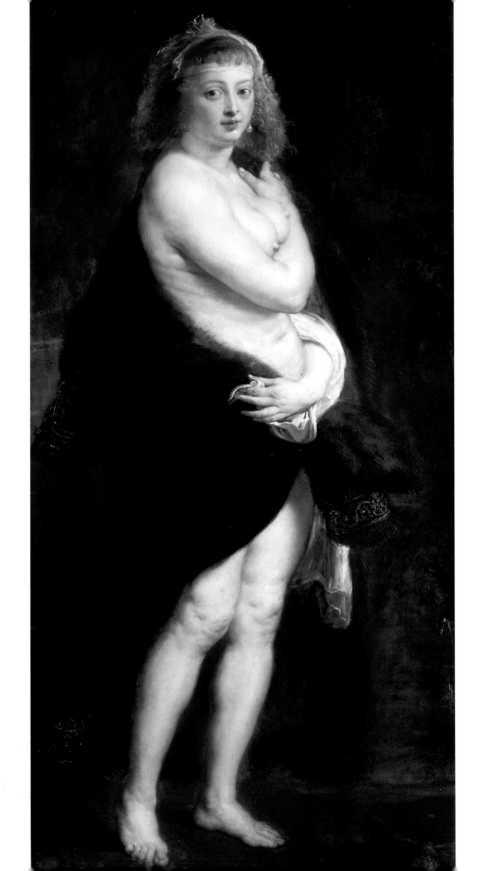

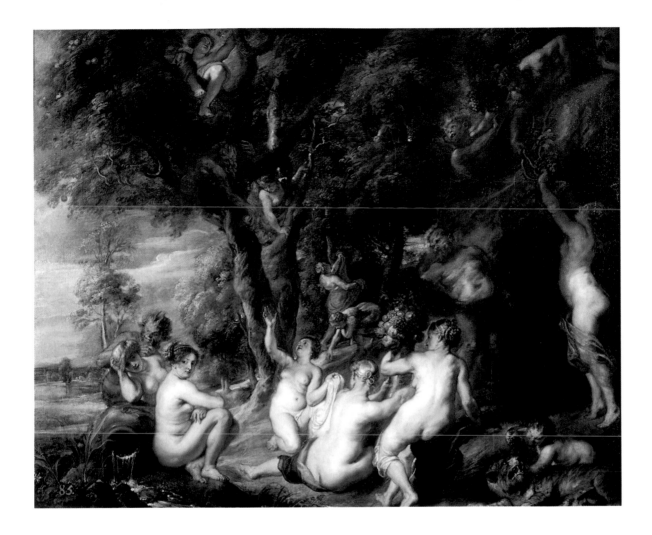

roar. All seem participants in a whirlwind of energy. But at the edges of this vortex, the movement slows and dissipates. The overflowing vitality of the figures is complemented by the bright colours, the pink, blue, yellow and violet dresses of the peasant women contrasting with the green of the pasture and the bright blue sky.

The Rubens who devoted the latter part of his life to the serenity of landscape and family life with his beloved Venus could congratulate himself on exhausting the thematic resources of painting. He had successfully painted every genre: scenes religious and profane, mythological compositions, portraits of royalty and intimate family portraits, and variants of pastoral and landscape. In his early career, episodes of drama and violence predominated – combat and rape. These gave way to the pathos of the Baroque and his own Baroque religiosity. He finished in glory, as a painter of familial and sensual love. His final *Self-Portrait* (p. 95) shows him dressed in black and wearing a feather hat, like the musketeer he had always been. Beneath the sunken lid glints an eye laden with the experience of life. He seems to have lived a blessed existence and in doing so to have reached a true serenity of heart. Gout alone had his measure. Despite the attentions of the

Diana's Nymphs Surprised by Satyrs, 1639
Oil on canvas, 128 x 314 cm
Madrid, Museo Nacional del Prado

PAGE 86:
Helena Fourment in a Fur Wrap ("Het Pelsken"), c. 1638
Oil on wood, 176 x 63 cm
Vienna, Kunsthistorisches Museum

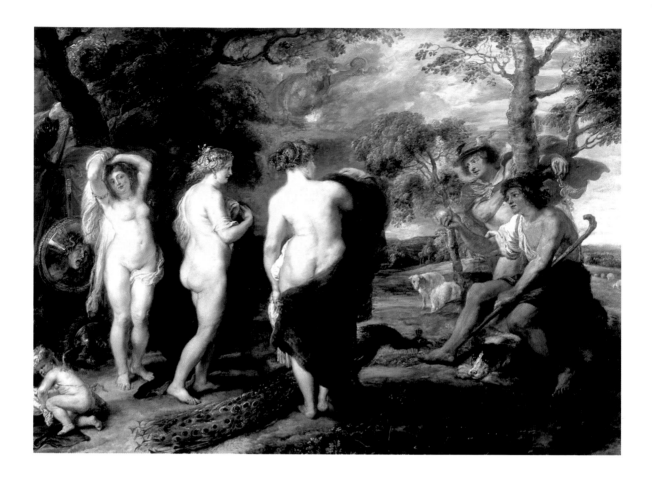

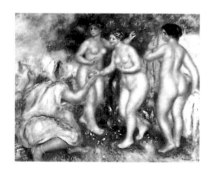

ABOVE:
Pierre-Auguste Renoir:
The Judgement of Paris, after Rubens, 1908
Oil on canvas, 81 x 101 cm
Japan, Private collection

AT TOP:
The Judgement of Paris, 1632–1635
Oil on wood, 144.8 x 193.7 cm
London, The National Gallery

best Brussels doctors, he died of a fierce attack on 30 May 1640, having two days before dictated his last will and testament, which provided for the division of his worldly goods between his wife and all his children. To Helena he left the work he loved most, *Het Pelsken*. He was buried in the church of Saint Jacob, beneath another of his paintings, albeit a very different one, *The Madonna of Saint George*. The apposition encapsulates the duality of the "Homer of painting". He remains, in everyone's eyes, the happiest of painters, his every painting redolent of his own exuberant pleasure in life. His genius brought to his native culture the conquests of Italian painting, and thus became the crowning glory of the Flemish school. He was the pre-eminent master and presiding spirit of an art born of but continuing beyond the achievements of the Renaissance.

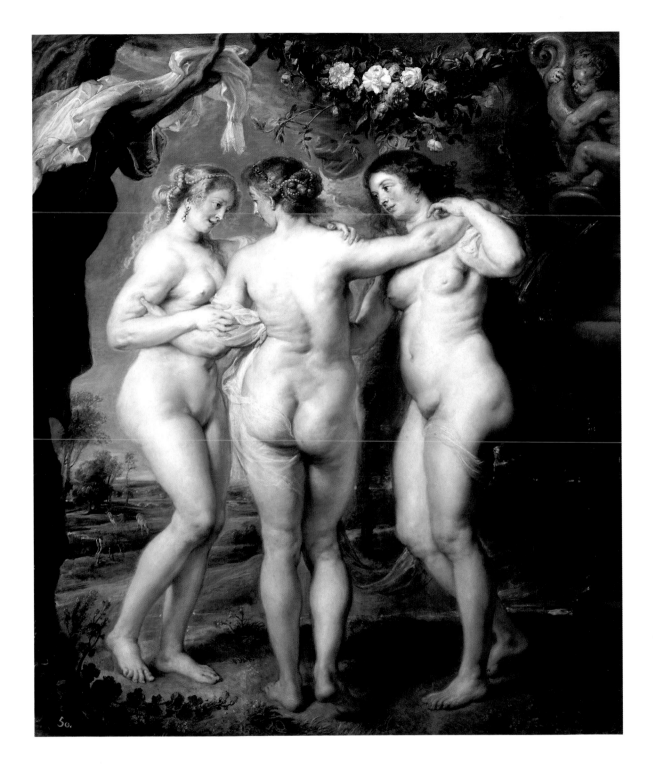

The Three Graces, 1636–1638
Oil on wood, 221 x 181 cm
Madrid, Museo Nacional del Prado

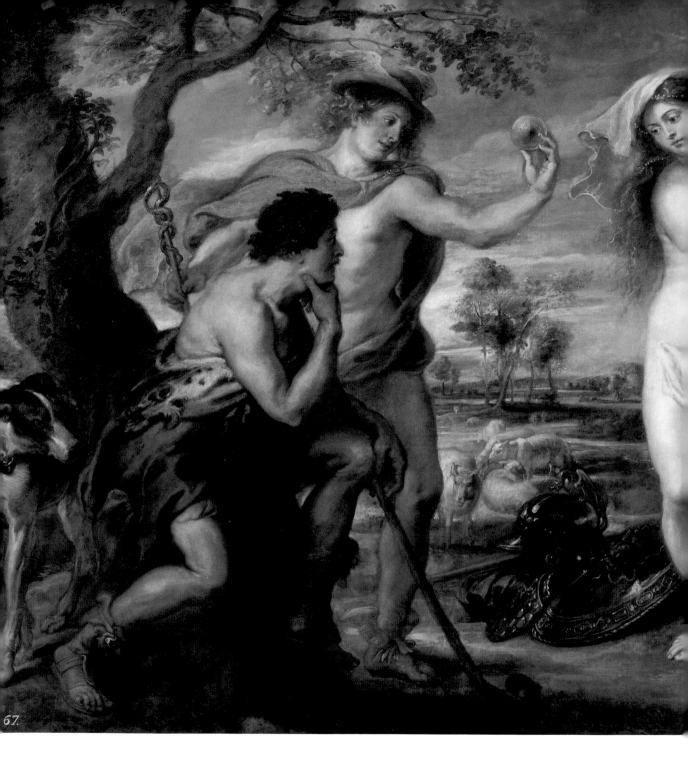

The Judgement of Paris, 1638–1639
Oil on wood, 199 x 379 cm
Madrid, Museo Nacional del Prado

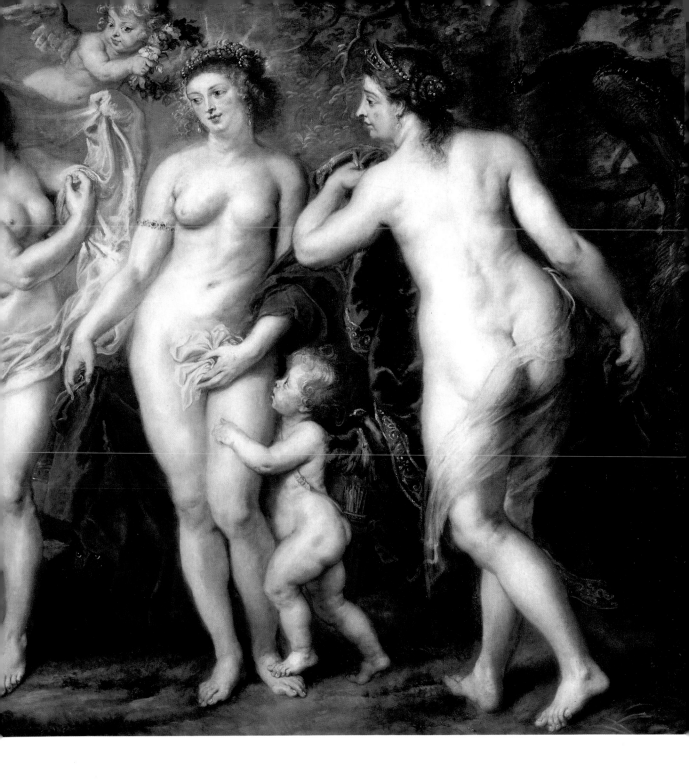

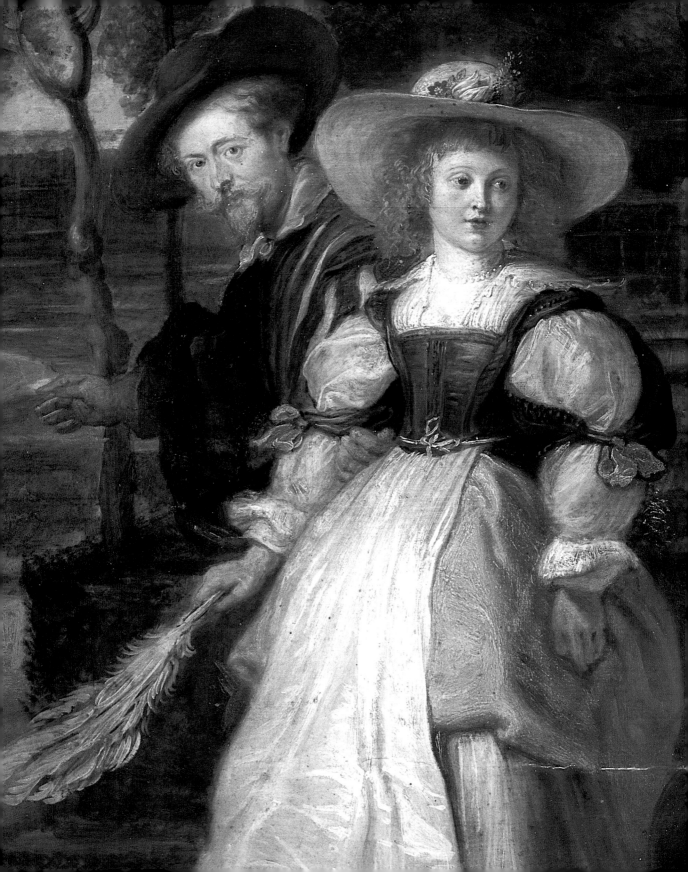

Life and Work
1577–1640

1577–1586 Peter Paul (Pieter Pauwel) Rubens believed himself to have been born in Cologne, where his Calvinist parents were living, having left Antwerp during the Spanish persecution of Protestants. There, his father, Jan Rubens, became the councillor and then lover of Anna of Saxony, wife of William I of Orange. Detection meant a mandatory death sentence, and he was saved only by the courageous intervention of his wife, Maria Pypelincks. Peter Paul was in fact born on 28 June 1577, in the little town of Siegen, west of Cologne, to which the Rubens family was exiled in commutation of the sentence.

1587–1599 Two years after the death of her husband, Maria Pypelincks returns to Antwerp with her two sons, Philip and Peter Paul, where they are well educated at the school of Rombout Verdonck. At thirteen, Peter Paul becomes a page to Countess Marguerite de Ligne-Arenberg. But this is not the life he desires: he wants to study painting, and begins to learn drawing by copying Tobias Stimmer's illustrations to the Bible. Then he is apprenticed for two years to a landscape artist called Tobias Verhaeght. He next works with Adam van Noort, before entering the studio of Otto van Veen, a painter of

considerable reputation and a devoted student of the Classics, who Latinized his name as Vaenius. Rubens is a redoubtably talented student. In 1598, he is admitted as a master to the painters' guild of St. Luke.

1600–1602 Thanks to his mother's support and his own evident talent, Peter Paul is able to realise his dream of travelling to Italy. In Venice, he admires the works of Titian, Tintoretto and Veronese, which contrast mightily with the mediocrity of his teachers' productions. There he meets Vincenzo I Gonzaga, Duke of Mantua, returning with him to his court.

1603–1607 The Duke enlists Rubens for a diplomatic mission to Felipe III of Spain; Gonzaga wishes to ingratiate himself by presenting works of art and other presents. Rubens commands the escort, and is well qualified to restore the canvases damaged during the trip. He is given an excellent reception in Spain, and takes the opportunity to paint a number of portraits (*The Duke of Lerma on Horseback*, p. 8) and execute commissions (*The Twelve Apostles*). On his return to Mantua, his "adoptive home", he studies the art of Mantegna, Correggio, Giulio Romano and Titian. His copies after Titian long

pass for originals. Gonzaga makes him a pension of four hundred ducats a year, and Rubens paints three masterpieces for him: *The Holy Trinity Adored by Vincenzo Gonzaga and his Family*, *The Transfiguration*, and the *Baptism of Christ*. Rubens now travels to Genoa, where he paints the *Portrait of Marchesa Brigida Spinola Doria* (p. 9). He then returns to Rome, where his brother Philip is pursuing his career as a librarian.

1608–1611 His mother falls dangerously ill. Having spent eight years in Italy, Rubens leaves hastily to go to her bedside, but arrives too late. He never returns to Italy. In 1609, the Archduke Albert and Archduchess Isabella (granddaughter of Holy Roman Emperor CharlesV) appoint him "Court painter" with a pension of 500 *livres* a year. Rubens is nevertheless allowed to reside in Antwerp. He paints for the Governor-Generals and soon receives major commissions from the municipality of Antwerp: *The Raising of the Cross*, *The Descent from the Cross* (p. 21), and the *Adoration of the Magi* (now in the Museo del Prado). Visiting his brother, Rubens meets Isabella Brant, niece of Philip's wife and then eighteen years old, whom he marries in 1609. Their happy union is celebrated

in the *Portrait of the Artist and his Wife in a Honeysuckle Bower* (p. 6); her hand rests trustingly on his. Two sons, Albert and Nicolaas, are born of this marriage, and a daughter who dies in her twelfth year. Rubens makes friends with the notabilities of Antwerp, such as Nicolaas Rockox, the alderman Gevartius, the Plantin-Moretus – a rich family of printers – and the painter Jan "Velvet" Brueghel. In 1611, he spends 7,600 florins on a townhouse on the Wapper (a street in central Antwerp), transforming it into a splendid Italian villa to house his growing collections.

1612–1621 Rubens shows all his prodigious industry. He gets up at 4 in the morning and works at his painting till 5 in the afternoon. In his studio, he is aided by numerous assistants (Snyders, Fyt, Van Thulden, and the famous Van Dyck); they execute paintings on the basis of Rubens' oil sketches. Rubens then retouches these works in greater or lesser degree. Religious works predominate in Rubens' first Antwerp period. But his productivity is such that profane themes also have their due. *The Last Judgement* (p. 28), *Lamentation* (p. 38), the various versions of the *Dead Christ* (pp. 16, 17, 20) and *Christ on the Cross* (p. 39), are answered in the pagan vein by allegories such as *Venus Shivering* (p. 23), *Bacchus* (p. 33), *The Rape of the Daughters of Leucippus* (p. 36), *Romulus and Remus* (p. 37), and *The Battle of the Amazons* (pp. 40/41).

1622–1625 Marie de' Medici commissions Rubens to decorate one of the great galleries of the Palais du Luxembourg, Paris, with paintings of events in her life. Political events prevent Rubens completing a similar series dedicated to the glory of Henri IV.

1626–1628 Isabelle Brandt dies aged thirty-four, leaving Rubens in despair and at odds with his art. To occupy

LEFT:
Rubens and His Wife Hélène, detail of **The Garden of Love**, (page 76), c. 1632–1633
Oil on canvas, 198 x 283 cm
Madrid, Museo Nacional del Prado

PAGE 95:
Self-Portrait (detail), 1638–1639
Oil on canvas, 109.5 x 85 cm
Vienna, Kunsthistorisches Museum

his grief, Rubens travels, undertaking various diplomatic missions, but the candid painter is sometimes disheartened by this world of intrigue. In 1628, he travels to Spain to meet Felipe IV and his minister Olivares; they are at first suspicious of this official ambassador, but soon warm to the cultivated man and superlative portraitist. Felipe rewards Rubens' portrait by granting him letters patent of nobility.

1629–1630 The Archduchess Isabelle appoints him her private secretary and sends him to England to solicit a rapprochement between England and Spain. He receives a cordial welcome from Charles I, who remains unconvinced by his arguments, but commissions him to paint portraits and undertake the decoration of the Banqueting House (glorifying the reign of glorification of James I). Charles knights Rubens. On his return to Antwerp, on 6 December 1630 he marries a ravishing young girl of sixteen, Helena Fourment, whom he was to cherish for the last decade of his life.

1631–1640 With his wife and their four children at his side (a fifth child is born eight months after his death), Rubens leads a comfortable life in his vast townhouse on the Wapper. He announces his retirement from political life. Strictly for his own pleasure, he paints a succession of late masterpieces, including several portraits of *Helena Fourment* (pp. 64, 67), the *Flemish Kermis* (pp. 72–73), *The Horrors of War* (p. 75), and the portrait of *Helena Fourment with her Children, Clara, Johanna and Frans* (p. 83). In the same year, he paints Helena as the three goddesses of *The Judgement of Paris* (pp. 90/91) and as *The Three Graces* (p. 89), then as his own "Venus in furs": *Het Pelsken* (p. 86). This is his favourite among his own paintings; refusing to part with it, he leaves it to Helena on his death. He also makes sketches for the decorations decreed in Antwerp for the entry of the Cardinal-Infante Fernando of Spain. In 1635, he buys the castle Het Steen in Elewyt, near Mechelen. There he spends every summer, painting a number of landscapes. In 1638, he survives a serious attack of gout, but in 1640 his health worsens. On 27 May, he makes his will. He dies on 30 May, having retained to the last his brilliant intellect and prodigious artistic vitality. He had just turned sixty-three.

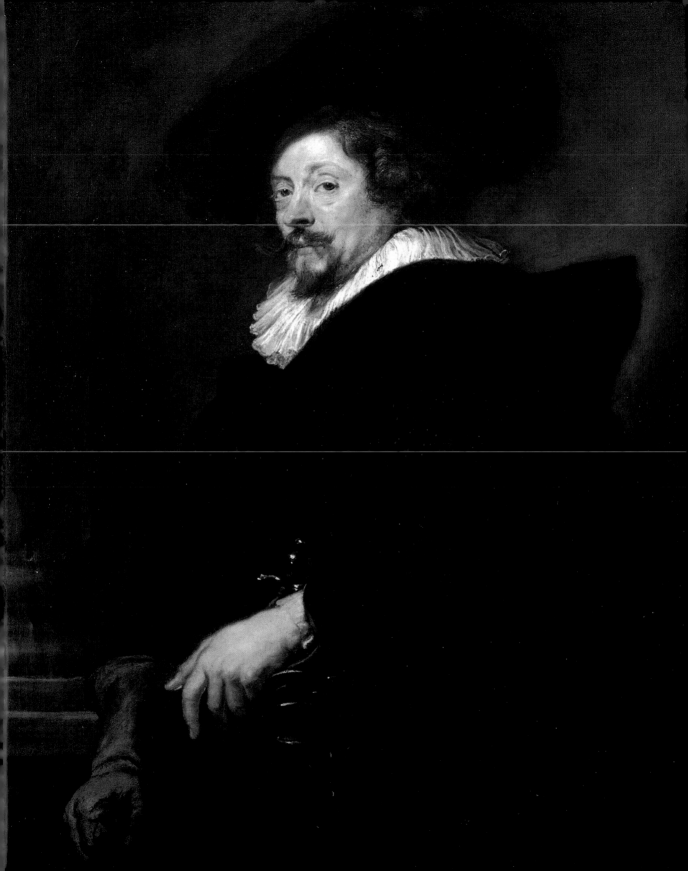

Acknowledgements and photo credits

The publisher would like to thank the museums and archives for giving permission to reproduce the works in this book. Unless stated otherwise, the copyright for the illustrated works is owned by the collections and institutions listed in the picture captions, or by the archives of TASCHEN Publishers:

AKG-images, Berlin: 11, 18, 26, AKG / Erich Lessing: 62/63, 70/71, AKG / Nimatallah: 95; SCALA, Florence, © 1990: 16, 22, 37, 80/81; Photolibrary Glasgow Museums, Glasgow, © photo: 24; Bridgeman Art Library, London: 20; Museo Nacional del Prado, Madrid, © Derechos Reservados: 8,44, 47, 48, 59, 66, 76, 77, 79, 84/85, 87, 89, 90/91, 94; Museo de la Real Academia de Bellas Artes de San Fernando, Madrid, © photo: 14; Museo Thyssen-Bornemisza, Madrid, © photo: 10; Colección Thyssen-Bornemisza, Monasterio de Pedralbes, Barcelona, © photo: 25; Yale University Art Gallery, New Haven, © photo: 13; Metropolitan Museum of Art, New York, photograph © 1983 (37.162): 69; National Gallery of Canada, Ottawa, © Photo: 17; RMN, Paris: RMN / Arnaudet: 78, RMN / Berizzi: 55, RMN / Jean/Lewandowski: 42, 51, 53, 54, 56/57, RMN / Lewandowski: 72, 73, 83, RMN / Ojéda/Le Mage: 49, 52, RMN / Schormans: 50; Philadelphia Museum of Art, Philadelphia, © photo: 19; Sammlungen des Fürsten von und zu Liechtenstein, Vaduz, © Photo Heinz Preute: 30, 35, 61; National Gallery of Art, Washington, Image © 2003 Board of Trustees: 9; Artothek, Weilheim: 27, 86, 92, Artothek / Bayer & Mitko: 28, 34, 67, Artothek / Joachim Blauel: 6, 45, 82 93, Artothek / Blauel/Gnamm: 33, 36, 40/41, 64, Artothek / Peter Willi: 21, Artothek / Bridgeman: 1, 2, 7, 12, 15, 23, 29, 31, 38, 39, 65, 68, 74, 75, 88.

Nude and Study of Head, c. 1920
Drawing with black stone and sanguine after Titian, 44.6 x 27.3 cm
Owner unknown